AMERICAN ART POTTERY

From the Collection of Everson Museum of Art

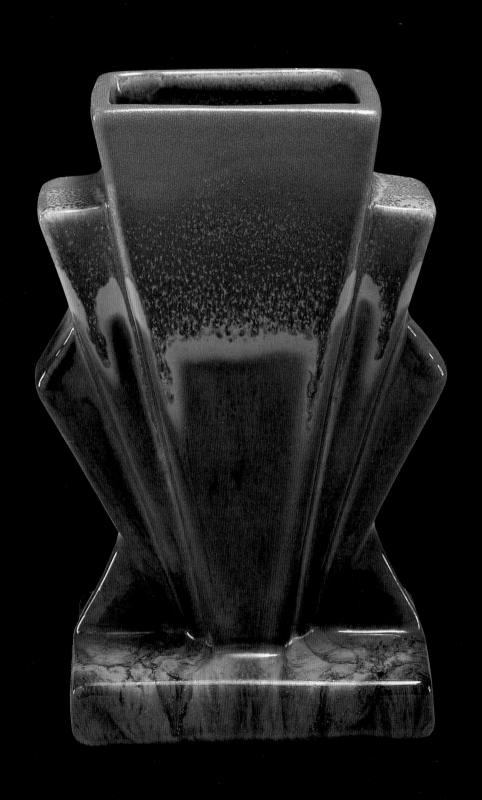

AMERICAN ART POTTERY

FROM THE COLLECTION OF EVERSON MUSEUM OF ART

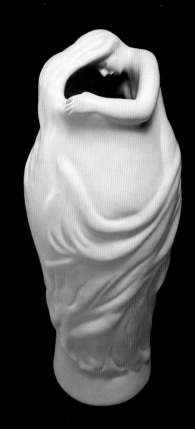

BY BARBARA A. PERRY

PHOTOGRAPHS BY COURTNEY FRISSE

HARRY N. ABRAMS, INC., PUBLISHERS

To Mary and to Norman
with many thanks to Michael Flanagan

CONTENTS

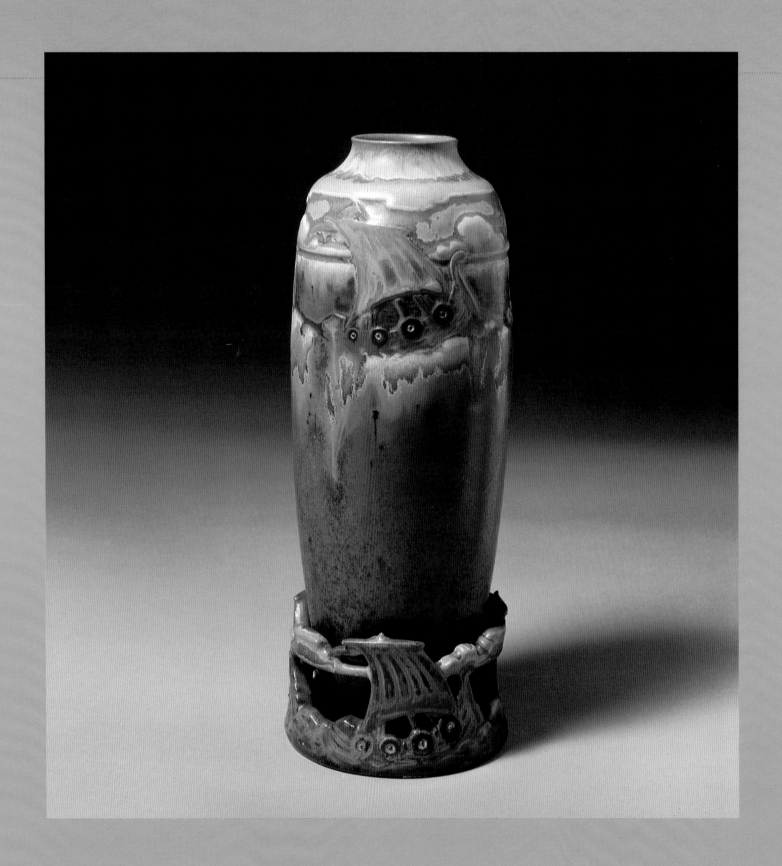

FOREWORD

The American art pottery collection at Everson Museum of Art has a history almost as old as the museum itself. It was begun in 1916 with the auspicious purchase of thirty-two porcelains by the renowned studio potter Adelaide Alsop Robineau, which were bought from the artist herself. Since that time, the museum has assembled a diverse collection of over more than fourteen hundred pieces from that era, representative of both the best handcrafted ceramics as well as examples of the commercial ware that helped to bring something of the spirit of the movement into the average American home. Today, the Everson's collection of American art pottery is one of the strongest components of the survey of world ceramics that is on permanent display in the museum's ceramics study center.

The lion's share of the American art pottery collection was generously donated over the last eight years by Mary and Paul Brandwein. Since 1988, the Brandweins have donated more than one thousand examples of art pottery to the permanent collection of the Everson. Among this large gift are representative works by most of the major potteries in production during the glory days of the movement, including Rookwood, Fulper, Grueby, Van Briggle, and George Ohr. A special feature of this collection is its encyclopedic array of production, as well as non-production objects, such as Roseville Pottery which has well over three hundred pieces. The thoroughness and dedication the Brandweins expended in putting this collection together have resulted in an aesthetic and educational legacy that a wide public will be able to enjoy and learn from for generations to come.

In addition to the generosity of the Brandweins, we must acknowledge the ceramic fund established in 1986 by Dorothy and Robert Riester of Cazenovia, New York. Spread over a three-year period, this fund enabled the Everson to purchase several exemplars of the American art pottery movement, among them a Newcomb Pottery vase decorated by Esther Elliot, a Grueby Pottery vase, and the spectacular *Hydrangea Vase* decorated by Albert Valentien of Rookwood Pottery.

The publication of this book is the result of the allegiance to Everson Museum of Art that Barbara Perry maintains even after her years here as curator of ceramics. Barbara's commitment to the field of ceramic scholarship has helped to elucidate many areas of the rich history of this medium, and for that we can all be grateful.

SANDRA TROP, DIRECTOR
Everson Museum of Art

Adelaide Alsop Robineau. VIKING SHIP VASE. 1905. Porcelain, H. 7¼, Diam. 2¾". Marks: conjoined *AR* in a circle excised; *570* incised—all on bottom of vase. On inside of ring base: incised cipher of conjoined *AR* in a rectangle. Museum purchase

Robineau had such control over her glazes that she could use them to gain specific aesthetic effects, such as the waterlike flow beneath the ships that conjures up the movement of the ocean.

INTRODUCTION

The art pottery collection of Everson Museum has grown by over twelve hundred pieces during the past six years. This reflects both the continuing commitment of the museum to the ceramic medium, and the exceptional generosity of dedicated donors. This expansion of the collection has prompted the publication of this book, a complement to the catalogue of Everson's ceramic collection published in 1989. This book must, however, take a different form from the earlier one. The art pottery movement has been well documented over the past several years, resulting in several important publications. It is not necessary at this point to present a detailed description of each pottery and its production. Instead, the collection itself has dictated the turn this study has taken. Everson's art pottery collection has become not just an assemblage of extraordinary ceramic objects, collected and displayed mainly for their aesthetic value, but now is a collection with a story to tell.

The judicious and farsighted collecting of Mary Brandwein, and her commitment to the preservation of American material culture, has been a benefit to many museums. Everson Museum is fortunate to have received her art pottery collection, which she has given with specific goals in mind. First, she knew that these objects must be preserved for future generations, and second, she wished that they be used to enlighten. An object may be beautiful in itself, and deserve to be enjoyed solely for aesthetic reasons, but other, more erudite issues should come into play as well. This collector assessed this collection and decided that it should someday enter a museum where it would be used to tell a portion of the story of American creative production and American taste. One, or even ten pieces, would not make a statement, but when there are over one thousand pieces, they become significant. They invite comparison and study. With the addition of the Brandwein gift, the Everson collection now illustrates the development of the entire art pottery movement, from the initial handcrafted pieces by T. J. Wheatley to the factory production at Roseville that mechanization allowed. It is this story, the story of American art pottery and what it says about ceramics and American culture, that is the subject of this book.

The idea that art pottery was handmade is a misunderstanding to a certain extent. Some art pottery was handmade, but by and large the products of these manufactories were made by hand only to varying degrees. The art pottery movement began with lofty purposes, most of them related to Maria Longworth Nichols's intention to "make cheap ware pretty." Hand craftsmanship was part of this purpose, but only until it was discovered that it was impossible to make pretty ware inexpensively by hand. Handcrafted wares took time, and time was money. In true American pragmatic entrepreneurial style, money won out.

Of course, the larger reason for this is that it takes a good deal of money to establish a pottery, and investors

do not usually invest in lofty ideals, but rather in tangible properties. They want a saleable product and a return on their investment. Thus, the art potteries were forced to produce, or close their doors (as many of them did). Many of those involved in the establishment of the early art potteries initially were china painters. They brought along the concept of painted decoration, meaning decoration applied to the surface of a vessel much as a painter applies paint to a canvas. This is a labor-intensive practice, and one which was continued over a long period only by Rookwood Pottery. Other potteries, Weller, Roseville, and Owens, for example, discontinued this decorative method after it was found to be expensive, and after other methods had been devised to replace it. Even Rookwood would ultimately turn to other methods of production (specifically, after Maria Longworth Nichols turned the pottery over to William Watts Taylor, who had to make a paying venture out of a pottery that had previously been generously subsidized by Mrs. Nichols).

Another reason for the acceptance of mechanized production by these potteries lies in the more general concept of the democratization of culture in America. One of the purposes of the art pottery movement, closely allied to the ideals of both the Aesthetic movement and the Arts and Crafts movement, was to provide objects for the use and edification of the middle classes (thus Mrs. Nichols's dictum to produce beautiful objects at a reasonable price). The Aesthetic and Arts and Crafts movements were aimed at providing a more comfortable and pleasing environment for the average person, particularly in the home. The objects that would achieve this purpose must obviously be within their economic grasp.

It is ironic that these wares, made for the consumption of the average person, have become so highly valued that they are no longer affordable to them. Now they are the purview of connoisseurs and collectors, museums and galleries, dealers and auction houses. Mary Brandwein, the consummate collector, has renewed the spirit of the Arts and Crafts philosophers and has returned her collection (assembled long before these objects became so highly valued) to the public venue. For her, collecting has been so much more than the satisfaction of an individual desire. Her collections, for she has many, have all been lovingly and carefully assembled with two thoughts in mind: to preserve some of the culture of the United States, and to make this available to as many people as possible.

For Mary, everything has meaning and is of interest. She likens her various collections to the world of nature, where every blade of grass, every weed, every plant, shrub, flower, and tree combine to make a garden. Her collections tell the story of America and its people. She is interested not only in the fine arts, but also in the simple everyday objects that often speak with great resonance of the common man.

Unlike many collectors, Mary's purposes are not just self-fulfillment or satisfaction. For her collection to be complete, she feels that it must be shared. She wishes to give others the pleasure of discovery that she experienced as she assembled her objects. She wishes to acknowledge the gift of the artists, as she in a sense continues their work by preserving their creations and presenting them for the enjoyment of others. Thus, this book is not only a celebration of the beauty of art pottery, it is also a celebration of goodwill and giving.

BARBARA A. PERRY

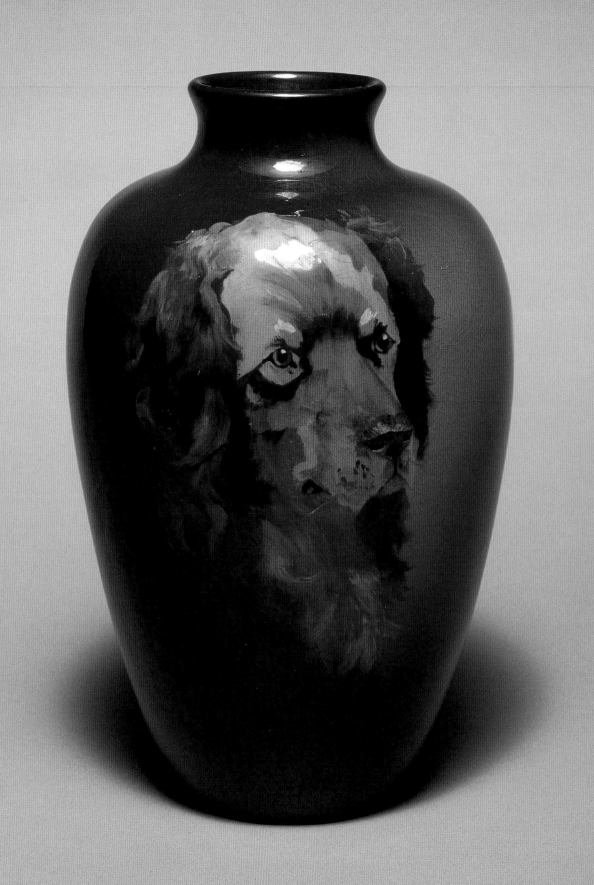

AMERICAN ART POTTERY

It is generally agreed that American art pottery was born in the studios and potteries of Ohio during the last quarter of the nineteenth century. It was here that many of these unique and winsome wares were produced, wares that are collected today even more avidly than they were at the time they were created. They are sought after by dealers, collectors, and museums, those who value them for their beauty and for the clear and illuminating statement they make about American taste and culture just before the turn of the century. Their loveliness also belies their industrial origins, for these potteries were, most of them, business ventures for which profit was the bottom line. Art pottery, like the period of its birth, was a combination of aesthetic yearning and pragmatic entrepreneurship.

America, recovered from the Civil War, was in the midst of a period of industrial growth. Railroads and canals provided transportation for both people and goods. They allowed for easy transportation of the raw materials necessary for the making of pottery, and when these had been transformed into the finished product, this transcontinental system carried it to all parts of the country. Art pottery was a national phenomenon, not a localized interest. Potteries sprang up from New England to California, and the larger establishments shipped their products all across the country, and even abroad.

This industrial growth gave rise to an ever-growing middle class, as it did in England and on the Continent. But this middle class in America differed in one very important way from its counterpart in England. Here in America there was a strong confidence and sense of certain opportunity to better one's position. There was no class system that squelched the ambitious or the accomplished. Anyone had the opportunity and the possibility to rise to a higher station in life. There were no boundaries, such as birthplace, occupation, or even accents of speech, that kept one from attaining, or even aspiring, to better living conditions and a better position in the community.

The desire for finer surroundings was part of this attitude, and the decoration of the home became of great importance. The influence of the English aesthetes William Morris and Charles Eastlake was being felt

Weller Pottery Co. Albert Wilson, decorator. LOUWELSA VASE WITH SPANIEL. c. 1895. Earthenware, H. 13½, Diam. 9". Mark: *Louwelsa/Weller* within a circle and *X481* impressed on bottom, *A. Wilson* brushed under glaze on back. Gift of Mary and Paul Brandwein

Animals were a favorite theme with a number of potteries. They were used to decorate trophies for hunting clubs and the like, as well as vases for general sale.

in America, and publications such as Eastlake's *Hints on Household Taste, The Ladies' Home Journal,* and *The House Beautiful* illustrated how the modern home should look, and provided women with the opportunity to plan a comfortable and aesthetically pleasing atmosphere. Modern conveniences, such as the sewing machine, washing machine, and commercially preserved food, allowed the woman more time for leisure and artistic interests. With greater interest in healthful living, heavy draperies and room darkening shutters were scuttled to make way for lighter, airier rooms with less bric-a-brac and clutter. The Aesthetic movement brought a greater feeling of simplicity and lightness to the modern home. The Arts and Crafts movement focused attention on the handcrafted and on purity of design. Both accented grace and ease of living.

Wallpapers, furniture, draperies, embroideries, bound books, screens, and even women's fashions reflected the change in taste, with subtle colors and harmonious design replacing the gaudy ostentation of the Victorian era. With this emphasis on good taste came a broadening, however slight, of the accepted role of women. Now it was deemed proper for women to participate in crafts other than embroidery (for centuries the only suitable pastime for women). Bookbinding, china painting, and other areas of the decorative arts were soon avidly pursued. This is not to say that it was acceptable for a woman to earn a living by such means, but it was proper for her to spend her spare time in such pursuits. An important part of this new lifestyle was the enjoyment of ceramics, from the creation of hand-painted china to the selection of ceramic objects to decorate the home. It was this climate that gave rise to and nourished the art potteries here in the United States.

BEFORE THE ART POTTERY ERA

Prior to the birth of American ceramics as an art form in the late nineteenth century, fine work had been done in this country during the previous hundred years. Bonnin and Morris of Philadelphia imported English potters who made soft-paste porcelain forms in the English style that were sought after by wealthy Philadelphians. Only a few precious pieces survive today, most in museum collections. Other potteries, most producing creamware, operated in that city, and in Trenton, producing wares derived from Staffordshire prototypes. Tucker and Hemphill produced porcelain with a neoclassic flavor, reflecting the American preference for the French taste during the early 1800s.

Greenpoint, New York, became a center for ceramic production, and remained so even into the art pottery era, with English and German sources for its products. Probably the best known of the early potteries were those at Bennington, Vermont, where Rockingham and parian wares were made in a variety of decorative shapes. But even in these early days, Ohio was a center of pottery production. Good waterways allowed for the easy transportation of both raw and finished goods, there was abundant clay, and the area attracted many English potters.

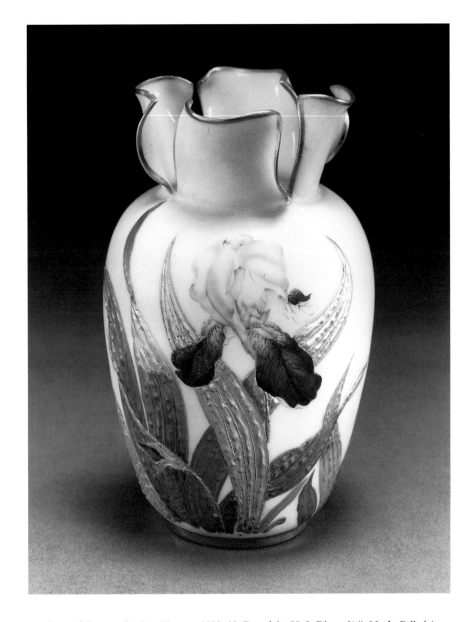

Ott and Brewer Co. IRIS VASE. c. 1882–92. Porcelain, H. 5, Diam. 3⅛". Mark: *Belleek/ crown and sword/Trenton, N.J./O&B* stamped on bottom. Gift of Kenneth L. Turk and Thora B. Ward in memory of Bernice F. Turk

With the expertise of immigrant Irish ceramists from Belleek, Ott and Brewer, in Trenton, New Jersey, produced an American version of the treasured Irish wares.

These early wares, however, were derived from European styles that had been in use for a hundred or more years, ever since the Germans at Meissen and the English at Minton had begun porcelain production. Just as importantly, the methods of production were European. Industrialization had struck the English potteries, like all other manufactories, and while there was still a considerable amount of handwork done, machines were used more and more, increasing production and lowering costs. Machinery was used to mix clay and grind glazes, pug mills replaced hand wedging, extruders were used to create handles, and transfers made decoration quick and consistent.

What sets art pottery apart from these early wares? In spite of the romanticizing that has been done about its origins, very little art pottery was handcrafted in the strict sense of the word. Its methods were, like the earlier wares, European derived, at least in the beginning. Some of it, most notably the early experimental pieces, are not even particularly attractive, with their awkward and ungainly decoration. But it has a peculiarly American quality to it. In the beginning it is brash and exuberant, without much sense of propriety. Its improvements are the result of experimentation and sheer good luck. In its Beaux Arts phase it exhibits all the eclecticism and extravagance of the late Victorian era, but then it matures and adopts the characteristics of the Arts and Crafts style, becoming more restrained and tasteful. Art pottery grew and matured along with the American public, for whom it was created. It reflects ourselves, our cultural milieu over a period of forty or more years.

INDUSTRIALIZATION AND THE CRAFTSMAN

Mechanization has been a part of the ceramic process since some potter devised the wheel thousands of years ago. The machine gradually infringed on the role of the craftsman until the first years of the twentieth century, when the production potter was replaced by the industrial designer and the studio potter. The art pottery movement in America witnessed this replacement.

The mechanization of ceramic production began early and took many forms. Clay for making ceramics was originally crushed by hand, the first step in its formation into a vessel or figure. A treatise on Italian pottery written by Cipriano Piccolopasso in the sixteenth century shows a crushing mill driven by donkey power. Crushing is now done by electrical power, but the results are basically the same. The clay is then mixed with water to the desired consistency and purified. Air must be removed from the clay to prevent explosions during firing. This is done by wedging, which involves cutting a block of clay in half with a wire and pounding one piece against the other. This is repeated until the clay is thoroughly mixed and all air has been removed. This was a very laborious and time-consuming process. Pug mills, which remove the air by a vacuum process, have replaced wedging by hand, and have become increasingly more efficient as their design has improved.

Molds for forming wares have been used since ancient times. The Romans, for example, made their tiny lamps by the thousands from molds. The European manufactories at Meissen and Nymphenburg used molds for both vessels and figures. Decoration can also be mold made and then applied to the surface, as in Wedgwood. There are various kinds of mold-making processes, from slip casting to pressing, or jiggering. These methods require some handwork, although now slip casting can be almost entirely automated. Today, roller machines are used, which spread and shape the clay in one automated operation, and require only unskilled labor.

Kilns have probably undergone the greatest changes, with electricity and gas replacing wood and coal, and greater insulation and more sensitive temperature controls allowing higher firing temperatures. The large beehive kilns of the eighteenth and nineteenth centuries, fired by wood or coal, replaced the smaller, less efficient kilns previously used. These giants were more efficient, held more pieces, and were easier to load and unload. The use of natural gas as fuel reduced labor, allowed for higher firing temperatures, and gave the potteries greater control over production, since results could be more carefully controlled. The area around Zanesville, Ohio, was rich in natural gas, which was a boon to the potteries established there. About 1918, tunnel kilns replaced the old labor intensive and unhealthy beehive kilns. Now, pieces were loaded on trolleys that passed through a long, tunnel-shaped kiln in continuous movement, with temperature changes automatically monitored and controlled. The wares emerged completely fired and cooled. Because there was greater temperature control, there was less waste and, thus, more profit. The control of the firing also meant that results were more predictable, and the quality of work improved. Glaze technicians and decorators could be fairly certain of the results to be obtained by the fire. Glazing was first done by dipping wares into vats of liquid glaze and allowing the excess to drip off. Glazing is now done by automated spraying.

Decoration involved extensive and time-consuming handwork for centuries. Surfaces have been painted upon since earliest times, and relief decoration is also traditional. It was not until the eighteenth century, with the invention of decals, that decoration became mechanized, but even these early decals required hand application. Underglaze decoration, typical of American art pottery, was done by painting with a brush on the surface of the vessel with slip, much like a painter applies oils to a canvas. Laura Fry, a Rookwood decorator, devised the method of applying background color with a mouth atomizer, and soon the process was accomplished with airbrushes. Overglaze decoration or underglaze slip painting was hand done, but then molded wares supplanted slip-painted wares as tastes changed and manufactories realized that molded decoration or decorative glazed wares could be more cheaply produced.

American art potteries were no different. When mechanization would cut costs and increase profits, it was eagerly adopted. While handwork was an important part of the Rookwood ethos, there was no aversion to the use of new techniques, especially when it came to efficiency of labor or cost. Almost from the beginning, Rookwood used mold-made wares as well as hand-thrown items for decoration. Originally, the pot-

tery produced tablewares on a commercial level, using decal decoration. True, the most important art pieces were hand decorated, but the forms were often mold made. The pottery quickly adopted the use of the atomizer for smooth color application, and advanced to the airbrush when it became available a few years later. The description of Rookwood pottery as handmade is not entirely accurate, in many instances.

Probably the most thoroughly mechanized of the major art potteries was Roseville. Roseville began as a typical art pottery in 1890, with most work done by hand. It was strongly influenced by the pottery produced by Rookwood, and at first imitated Rookwood Standard wares. Roseville, unlike Rookwood, was a commercial venture from the beginning, and quickly adopted and adapted to new technology. Soon after 1908 all decoration by hand was abandoned, with the exception of some Rozane Royal wares, Roseville's original prestige line.[1] By 1919 Roseville had ceased to produce hand-decorated wares entirely.[2] Mold-made wares, well designed and technically refined, replaced the traditional slip-decorated pieces, which had gone out of style and were expensive to produce. Roseville was the first art pottery to install a tunnel kiln, and the volume of production became very high. Roseville technicians developed glazes that were inexpensive to produce, one being the oxblood type usually so costly to use.

From the beginning there was a division of labor in American art potteries, just as there had been in England. The production methods and factory organization of American potteries also were derived from those in England, mainly because most of the ceramic workers in this country came here from England, either in search of more steady jobs when the English potter industry was depressed, or by invitation from American potteries seeking experienced workers and technicians. This was especially true during the earlier years of the nineteenth century, in manufactories such as Union Porcelain Works in Green Point, Long Island; Ott and Brewer in Trenton, New Jersey; and Knowles, Taylor and Knowles in East Liverpool, Ohio. The work produced was in the traditional English style, both in form and decoration.

The English Arts and Crafts movement was given a purely American accent in this country. At first glance, the mechanization that developed in the American art potteries seems antithetical to the ideals of the Arts and Crafts philosophy, but American adherents to this belief accepted the use of the machine to a much greater extent than did their English counterparts. While William Morris and John Ruskin eschewed the machine, seeing it as the primary cause of the degradation of humanity, American craftsmen saw it as a labor-saving device, a boon to the average worker. Gustav Stickley used the machine to create dowels and dovetails, and added cast hardware to his pieces. The machine was used to save time and labor in construction, which could then be used for fine hand finishing. Frank Lloyd Wright was a follower of Morris, too, though he felt that he miscalculated the value of the machine. Americans were not adverse to saving time, energy, and money if the aesthetic value of the object was not jeopardized. This was also true of the art potteries in this country.

WOMEN IN THE ART POTTERIES

As in the English potteries, tasks were divided and seldom shared. There were throwers, kiln men, clay workers, decorators, mold makers, and laborers. At the top of the echelon were the designers and decorators, with the technicians on a par with them. Many of the decorators were women, but there are no records of women throwers or clay workers. It was unthinkable during that period for a woman to work at such an untidy task as throwing clay. Decorating, on the other hand, was seemly and appropriate work for a woman. It was delicate work, akin to painting or drawing, also acceptable practices for a woman during the period.

In American potteries, there seem to have been fewer of the petty jealousies that pervaded the English decorating rooms, where women were held in much lower esteem, and indeed forced to work under more difficult circumstances than the men. For instance, in one English pottery women were not permitted to have an arm on their chairs to support their wrist while working, giving a distinct advantage to the male decorators. Women were also often paid on a lower scale than the men.

Women were more readily accepted in American ceramic establishments than they were abroad. Americans, having built a civilized country from a wilderness in only a short time, were intensely practical, innovative, and hardworking. Women, of necessity, had always been expected to participate in these endeavors. This more active participation was usually undertaken not because of any philosophical attitude toward furthering the rights of women, but purely for practical purposes. Women were simply needed in the day-to-day work of establishing this country and in the movement west. Some women needed to support themselves, or in many instances had innovative ideas to offer or aspirations to achieve certain ends, and simply did whatever was necessary to accomplish this. It was not unusual for an American woman to exhibit confidence, intelligence, and a sense of determination. As a result, American women found it easier to assume a place in business or in the arts than did their European counterparts.

This is not to say, however, that women in this country had carte blanche in a field dominated by men. Women still had their place. They were often still relegated to "womanly pursuits," though here those pursuits covered a broader range than they did in Europe, where the role of the woman was much more bound by tradition. American women were not usually expected to perform tasks that would get them dirty, or that required any amount of strength. There was also a certain disdain of the intellectual abilities of women.

It is an interesting dichotomy that in the American art potteries there was a definite attitude about the appropriate positions of women, and yet many of the most important figures in the art pottery movement in this country were women. One of the reasons that traces of the European concept of the role of women in ceramics prevailed in many American art potteries was the fact that many American potteries, in the for-

mative years of the movement, employed English workers. These Englishmen brought with them years of technical experience in pottery making, something very scarce in a country without a real ceramic tradition of its own at that point, but they also brought with them very ingrained ideas about the proper role of the sexes in the performance of specific jobs in ceramic production.

Women had always done minute, detailed handwork, so decorating was considered appropriate for them. It was careful, time-consuming work for which women, supposedly, were better suited than men. Women also worked in the showrooms. They were selling wares for the home, to be purchased and enjoyed by women, so it was reasoned that this was also a proper position for them. It was clean and "genteel" work. In the larger production potteries, women did not throw forms, nor did they usually become involved in the creation of glazes or clay bodies. These more technical matters were left to men. Nor did women fire the kilns, nor load and unload them. These jobs, too, were the provenance of the men or young boys. At least one pottery, Henry Chapman Mercer's Moravian Pottery and Tile works in Doylestown, Pennsylvania, never hired women at all.[3]

On the other hand, however, some of the prime movers in the movement were women, and many of the more important discoveries and innovations that led to the distinguishing qualities of art pottery were made by women. In the very earliest years, the whole impetus to the movement came from women working in clay and china painting in Cincinnati. Mary Louise McLaughlin is usually credited with the discovery of the decorating method known as Cincinnati faience, whereby colored slips were applied to the surface of the damp clay body in a painterly fashion. Upon firing, the results were similar in appearance to oil painting. McLaughlin eventually turned her interest from slip decoration to the production of hard-paste porcelain. She was successful at this and won a bronze medal at the 1901 Pan-American Exposition at Buffalo. Maria Longworth Nichols abandoned china painting to create sculptural decoration on vessels. Her rather grand ideas came to fruition in the establishment of Rookwood Pottery, one of the first, and the most successful, of the art potteries. She ran the pottery herself for the first three years, until she hired a business manager. Rookwood decorator Laura Fry discovered that glaze could be applied evenly and in subtle gradations of color with the use of an atomizer, and a new style was born, one copied by many other art potteries during the period. Fry also could throw on the wheel, and was one of the few decorators at Rookwood who also designed shapes. Anna Marie Bookprinter Valentien did sculptural work for the pottery, a technique usually reserved for men.

In addition to the rather incredible burst of activity that took place in Cincinnati, there were exciting and innovative things happening in other areas of the country as well. Susan Frackelton was a china painter in Milwaukee, Wisconsin, where she established the National League of Mineral Painters. She, like so many other women who began as china painters, moved away from that technique and became involved in ceramic production. She went on to create art ware from salt-glazed stoneware, one of the few Americans to use this

material for other than utilitarian purposes. Mary Chase Perry Stratton established Pewabic Pottery in Detroit and was skilled in the development of forms and glazes, particularly iridescent glazes. Pewabic became a nationally known producer of architectural tiles, which graced such buildings as the Cathedral of St. John the Divine in New York, the crypt of the Shrine of the Immaculate Conception in Washington, D.C., and the Detroit Institute of Arts. They were also used in many residences.

Newcomb Pottery was established as a part of Newcomb College (the women's branch of Tulane University) in Louisiana for the education of women, providing them with the means to earn a living. Typically, though the pottery was established for women, the instructors, with one exception, were all men. Mary Sheerer was hired to oversee the women. Sheerer gained experience in ceramics and made significant contributions to the development of clay bodies and glazes at Newcomb, but she was never recognized by the Newcomb management for her contributions.

Pauline Jacobus established the Pauline Pottery in Chicago, later moving it to Edgerton, Wisconsin. Jacobus, with her husband, ran the pottery, designed forms and experimented with clay bodies and glazes. The Overbeck Pottery in Cambridge City, Indiana, was established by four sisters who performed all of the production work themselves. The Saturday Evening Girls, later to become the Paul Revere Pottery, provided instruction and employment for immigrant girls, although some of the work, such as firing of the kiln, was done by men. The girls learned not only to decorate, but also to design and glaze. The pottery was also directed by a woman, Edith Brown.

Probably the most important woman of the era was Adelaide Robineau. Robineau started a production pottery in Syracuse, New York, but soon gave up the idea in favor of producing her own work in porcelain. She created her own clay bodies (using native materials whenever possible), glazes, and did her own firing, assisted by her husband, Samuel. She learned the entire ceramic process herself, with only a few weeks of formal instruction at Alfred University under Charles Binns. Robineau was an experimenter in the image of Leonardo. Once she had mastered a technique or problem, she seldom returned to it, preferring to go on to some new challenge. She not only produced exquisite porcelains, but also published a periodical, *Keramic Studio*, which instructed her readers in the china painting technique, and also served as a vehicle for the dissemination of her Arts and Crafts ideals.

An important figure at Rookwood was Sally Toohey, who was sent to France by the pottery for further study. She designed many new shapes for the pottery, and eventually was put in charge of glazing, first in the architectural tile department, then in the vase department. Anna Marie Bookprinter Valentien, another Rookwood decorator, also went abroad to study, first in France and then in Germany. She was a sculptor who produced exquisitely modeled wares for the pottery, as well as traditionally decorated pieces. Later, she and her husband, Albert, went to California, where they painted wild flowers and established their own pottery.

Anna Van Briggle was a sculptor who modeled forms for the pottery established by her husband, Artus,

in Colorado Springs. Upon the death of her husband from tuberculosis, Anna assumed the presidency of the pottery and continued to operate it for a number of years.

While many of the important figures in the formation of the American art pottery movement were women, women were really not, as a rule, in positions of responsibility in the potteries. The women who gave impetus to the establishment of potteries, such as Maria Longworth Nichols or Mary Chase Perry Stratton, hired plant managers who were men, and had male business managers as well. There were few women available with many of the skills needed in the daily operation of a pottery, for women were never taken on as apprentices, and were not admitted to the few schools of ceramics in the country (Alfred did accept a few women, but always in ceramic design, never in ceramic engineering). Most of the women who became designers in the early years came into the profession from china painting or had been trained in the fine arts, in drawing and painting. They had not, strictly speaking, come from a pottery tradition. Perhaps this is one of the reasons that American pottery has a distinctive quality. It was not mired in the restrictions of tradition.

In none of the large production potteries, such as Roseville, Weller, Owens, or the later Rookwood, did women play an important role except as decorators, or in a few instances as designers. In most cases, they did not create glazes or clay bodies, make decisions about marketing, manage the potteries, work in the molding rooms, or assist in firing. There were exceptions, of course, such as the Overbeck sisters, Robineau, and Stratton. But these were the exception, not the rule, and they established their own potteries, where they could be in control. But it is significant that women played an important part in the formation of the movement, and that many of the finer artists were women.

PEOPLE AT WORK

Working conditions for the pottery employee varied a great deal according to the position and the manufactory. Even in potteries that ascribed to the enlightened ideas of the social reformers, maintaining a healthful and pleasant, not to say congenial, atmosphere was very difficult. Each of the many phases of pottery production contributed its own set of hazards and inconveniences.

One of the most annoying and debilitating was the dust. By nature, potteries are dusty places, and in an age where air purification had not even been considered a possibility, the air quality was abysmal in most establishments. First, the grinding and mixing of the dry clay created a good deal of dust, and the finishing areas contributed even more. Just the movement of people about the building and rooms stirred up the dust. This was much more of a problem in the smaller potteries, where people worked in close proximity. Photographs reveal decorators in small potteries wearing head coverings to keep the clay dust out of the hair, since the decorating rooms were in the same building as the production section of the pottery. This was less

troublesome for decorators in larger manufactories, since there were separate sections for each phase of manufacture and the decorating rooms were farther removed form the mixing and forming areas.

Nuisance aside, the dust was also terribly unhealthy, and silicosis was a common disease among pottery workers. One is amazed at the dedication of Artus Van Briggle to his art, considering the effect the dusty atmosphere must have had on his tubercular lungs. And it is rather appalling to learn that Arequipa pottery was established to provide occupational therapy for working class women with tuberculosis. Even though the patients were involved only in the finishing and decorating, the dusty atmosphere must have been unhealthful.

The dust that pervaded the potteries was not only clay dust, but dust created by the mixing and grinding of various minerals for glazes. Though potters had known for years of the hazards of lead, many at this point were still unaware of the effects of breathing the dust of the myriad minerals and chemicals used in the concoction of glazes. For example, John Herold, an Austrian who worked at Weller Pottery, damaged his lungs by inhaling fumes while developing copper glazes, and had to move west for his health.[4] Skin was also often affected by the clay and glaze materials, to say nothing of the constant exposure to extreme dampness or dryness, depending on the phase of clay production the worker was engaged in. The huge bottle kilns belched dense smoke, sooty and acid laden, that was a health hazard not only to the pottery workers themselves, but also to the population of the entire surrounding areas.

Wages for most clay workers were meager. Decorators and designers were highest paid, along with throwers and technicians. Even among the decorators, pay was calculated according to quality of work. Women, however talented, were paid less than the men. The less skilled the laborer, the less his wage, as in other industries. Use was also made of young school-age children as decorators or as "runners," who carried work from one work area to another. Grueby employed schoolgirls to add the filleted decoration to their vases, and other potteries employed part-time unskilled workers to perform repetitious decorating jobs, freeing the more skilled workers for finer work.

Jealousies were the norm in decorating rooms, though this varied in severity from pottery to pottery. Competition between potteries was keen, for they all were vying for the same market, and decorators often moved from pottery to pottery, taking their styles and secrets with them. Rookwood was the first to produce what is called "Standard" ware, with its dark brown background and underglaze slip decoration, but other potteries soon followed their lead. Laura Fry, the decorator who discovered the atomizer technique, moved from Rookwood to Lonhuda Pottery, after a stint as a teacher at Purdue University. Lonhuda became a part of Weller Pottery shortly after, and the Lonhuda line was renamed Louwelsa. Thus began the passing of the Rookwood style from pottery to pottery.

Jacques Sicard came to this country from France in 1901 and was hired by Weller Pottery in 1902. Sicard had perfected a decorating technique which resulted in deep, rich iridescent effects, which became a hallmark of Weller products. Sicard was extremely secretive about his work, and allowed no one in his work-

room while he was decorating.[5] When he returned to France in 1907, his secrets accompanied him, and Weller ceased to produce Sicard ware.

Hester Pillsbury worked at Roseville and Weller. She was friendly and congenial with her coworkers, but very secretive about her work. She worked quickly, and kept her work behind a screen so that no one could copy it.[6]

Even the famous Taxile Doat did not share his expertise when he came to work at University City in St. Louis with Adelaide Robineau. Robineau had looked forward to working with the noted French ceramist, realizing that she could learn much from him. But Doat concentrated on decoration only, and relegated the production of forms to his assistant, Emil Diffloth, who proved to be most uncooperative.[7] He refused to share his glaze and clay formulas with anyone else, working only for Doat. Diffloth was jealous of Doat, and would not cooperate with Mrs. Robineau at all. It must have been a most uncomfortable working situation.

There were, of course, many others who were willing to share their knowledge. John Herold worked as a team with Frederick Hurten Rhead at Weller Pottery, and would help others with the development of clay bodies and glazes and with decorative processes. While other itinerant workers carefully guarded their secrets, Herold established a company file, with records of recipes and formulas, all for future reference and experimentation.[8]

Adelaide Robineau was also very eager to share her ideas and knowledge. She provided leadership in the field with her publication *Keramic Studio,* and taught ceramics at Syracuse University. When Robineau died of leukemia in 1929, she bequeathed her formula books to one of her students, Carlton Atherton. They are now in the archives of Ohio State University in Columbus.

Frederick Hurten Rhead also published extensively, and shared his knowledge and ideas concerning ceramic production with a wide audience. He published *The Potter,* a monthly magazine which included articles on most phases of the pottery business. Rhead was not a good businessman, however, and the publication failed after only three issues, but the fact that he even undertook the venture underscores his eagerness to share his extensive knowledge of pottery making. He also wrote a column, "Chats on Pottery," for the *Potters Herald,* and frequently contributed to Robineau's *Keramic Studio.*

It is unfortunate that the vast majority of the designers and decorators exist only as names to us. Nor do we know even the names of most of the technicians and glaze developers. We know the work of artists like Albert Cusick (Avon Faience Company, among others), Annie Brinton (Edwin Bennett Pottery Co.), Madge Herst, or Gussie Gorwick, both of whom decorated for Roseville, but we know nothing about who these people were or what they were like.

We can infer some things about some of the better-known personalities of the period. For instance, Adelaide Robineau must have been a very energetic and focused woman to be able to accomplish all that she did. Maria Longworth Nichols must have been determined and stubborn, and probably more than a lit-

tle spoiled, accustomed to having her way. Frederick Hurten Rhead might have been a bit of a philanderer, having married three times. Or perhaps he, like Piero, was too enamored of his art. Hugh Robertson's drive to discover the secret of making oxblood glaze indicates his preference for artistic achievement over financial success, for he finally was forced to close his pottery for lack of funds.

There are a few artists about whom we know a little. Robineau's daughter has reported that her mother was very frugal, often asserting that they were about to go over the hill to the poorhouse, when actually they usually went to France instead.[9] Sicard was notoriously secretive. The Timberlake sisters, Mae and Sarah, were very close. Mae was very timid, while Sarah was outgoing and friendly, but they always worked together. Mae was the more talented of the two, but she refused to work for any pottery unless Sarah was also hired. They worked side by side, and each day Sarah would set out Mae's brushes and paints for her. It is said that Mae would not even board a bus without her sister.[10] Gazo Fujiyama (also known as Gazo Fudji) was a Japanese artist who had spent much time in Europe. He was well educated and comfortable in Western society. The Chicago *Chronicle* once described him as a "suave Japanese artist."

Romance in the potteries was not unknown, either. Frederick Hurten Rhead met Loiz Whitcomb when she worked as a decorator at his pottery in Santa Barbara. Rhead divorced his first wife, Agnes, and married Loiz. They, in turn, divorced at a later date. The Valentiens, Albert and Maria, met at Rookwood Pottery, where both worked in the decorating room. After their marriage, they went to Europe to study and paint. Later, they established their own pottery in California. Artist Anne Gregory encouraged Artus Van Briggle to open his own pottery in Colorado Springs, and eventually they were married. Anne continued to operate the pottery after her husband's death. Mary Chase Perry would marry William Buck Stratton, who designed her pottery building on East Jefferson Avenue, in Detroit.

These are only a few of the hundreds, even thousands, of people who were involved in the production of these elegant wares we value so highly today. There were people from all rungs of the pottery ladder who were indispensable in the day-to-day workings of the potteries. The artists, of course, have been given the most attention simply because it is their genius that has made the ware so successful. But there are many behind-the-scenes workers who are seldom considered, and will never be recognized simply because they are, in most instances, unknown. There are glaze chemists, technicians, kiln men, designers, production managers, even clay workers, and runners, all of whom played a part, large or small, in the success of these ventures. It is unfortunate that most of them will never be recognized.

THE POTTERIES

Rookwood Pottery, Cincinnati, Ohio When Joseph Longworth gave his daughter Maria an old school-house for use as a pottery, little could he have known that this was the beginning of a whole new phase in American ceramics. His headstrong daughter would establish in that old building the most important of the art potteries that sprang up around the country at the turn of the century. Rookwood was on the cutting edge of the evolution of style for years to come. Maria's venture grew out of the china painting vogue that struck America during the last half of the nineteenth century.

The technique for painting on china had been introduced to this country in 1861 by Edward Lycett,[11] who had received his training in his native England. He worked for Faience Manufacturing Company in Greenpoint, New York, and later traveled about the country giving lectures and demonstrations in his art. He did, at one point, spend some time in Cincinnati, where Maria Longworth Nichols undoubtedly met him. Ben Pittman had introduced the china painting technique to the women of Cincinnati,[12] conducting classes which were attended mainly by well-to-do women with leisure time on their hands. China painting involves painting in mineral colors on the glazed surface of a fired porcelain body (called a blank). The piece is then fired, making the decoration permanent. Once women learned the technique, it became apparent that china painting was potentially a profitable venture, and soon it became an acceptable means of livelihood for women who had to support themselves. Women could sell their wares, or even better, could become teachers themselves, adding to their income.

Mary Louise McLaughlin, a Cincinnati woman who had studied china painting at the School of Design in that city, wrote a book on the technique, *China Painting: A Practical Manual for the Use of Amateurs in the Decoration of Hard Porcelain*. She explained the technique, described the necessary tools for its execution, and discussed the importance of using designs appropriate to the forms being decorated. The book was an immediate hit, and sold well for several years.

Adelaide Robineau began her professional career as a teacher of china painting, and established her publication, *Keramic Studio*, for the purpose of instructing women in the art and also to encourage experimentation and exploration of modern design. Her folios were a valuable source of inspiration, information, and motifs.

Initially, the subject matter preferred by these china painters centered mainly on floral motifs, fruits, or other subjects concerned with nature. As the teachings of Robineau and other forward-looking artists were disseminated, stylization appeared, and the wares developed more of an Arts and Crafts look. Plates were most

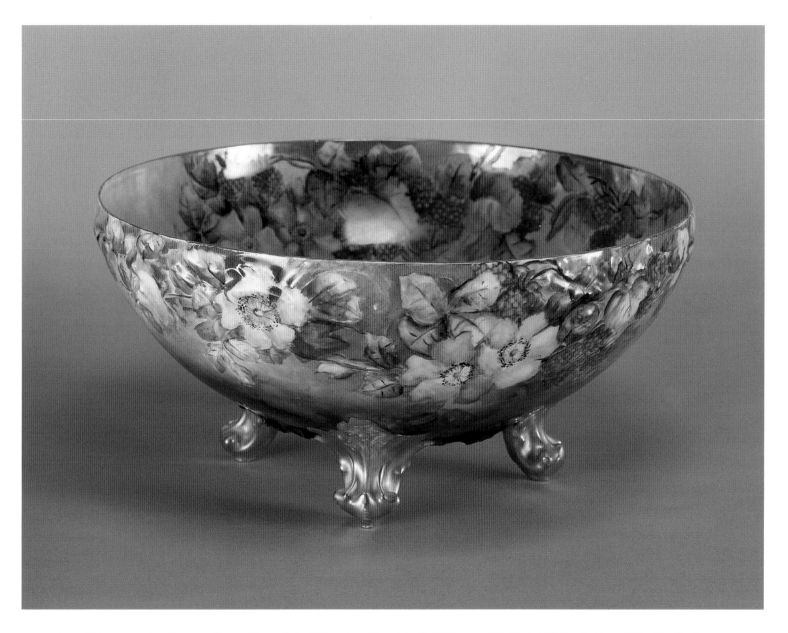

Anna Fisher, decorator. Painted Punch Bowl. Late 19th century. Porcelain, H. 6¾, Diam. 14¼". Mark: *T &V* on bottom. Gift of Sophia Cooney

This punch bowl, with its attendant gobletlike cups (not pictured), illustrates the taste of the late Victorian period which was so prevalent in much of the early china painted wares done in this country prior to the influence of the Arts and Crafts movement from abroad.

popular, but cups and saucers, tea, coffee, and chocolate sets, and various other tableware were also favored.

Maria Longworth Nichols had done overglaze painting since 1873. This, in turn, led her to undertake the decoration of unfired vessels, a very different technique from china painting. Nichols set about to learn to paint in slip on an unfired body, with the glaze being added after the decoration. She set up a studio at the pottery of Frederick Dallas, where she had the advice of professionals to help her solve the many problems she encountered in learning this new technique. Soon she set up her own pottery in the schoolhouse provided by her father, calling it Rookwood because the name reminded her of Wedgwood, and because it was the name of her girlhood home, for which she had fond memories (it has been said that her marriage to George Nichols was not a happy one).

Initially, Rookwood's production was scattered. The pottery produced blanks for decoration by local amateurs, and tableware which, it was hoped, would provide income to support the experimentation with the art wares. The pottery also fired decorated wares for outsiders, including members of the Cincinnati Pottery club, which rented space from the pottery. The pottery was subsidized by Mrs. Nichols for the first three years, and then a business manager, William Watts Taylor, was hired when Mrs. Nichols realized that she could not manage the business and continue to experiment with her own work too. Taylor put the pottery on a business-like footing, reorganizing it in most areas. William Auckland was hired to throw pots on the wheel, and other decorators were soon added to the staff.

The early art wares produced at Rookwood often betrayed the experiments being conducted by Mrs. Nichols and the staff. Some of the shapes were rather ungainly, and the decorating uncertain, and, in true Victorian fashion, often on the verge of gaudiness. The typical "Rookwood look" had not yet been realized. These early forms were often exotic, and Maria's own work sometimes approached the bizarre. She was fond of sea creatures, and had fallen under the spell of the Japan craze that was sweeping the country at the time. She modeled dragons and other sea life and applied them to the shoulders and rims of her vases. She often lavished these pieces with gilding, creating highly unusual effects.

Maria had initially been inspired to do underglaze painting after seeing French barbotine wares at the Philadelphia Centennial Exposition. (Barbotine ware is decorated with colored slips under the glaze, in a painterly fashion.) She was also influenced by the work of the Gallé pottery, and sought to imitate their wares. A tankard in the Everson collection illustrates her debt to Gallé, for she has used a Gallé form and the decoration imitates a motif used at the French factory.

In the early years, the artware produced at Rookwood used this underglaze technique combined with a smear glaze. The resulting surface was textured, for the glaze was thin and matte, and the decoration seemed to float on the surface. It is difficult for the casual observer to see the glaze, for it appears to be absorbed by the body. Backgrounds were usually light, or lightly colored and blended, though a bright blue was also used. Stamped decoration was often incorporated with the painted decoration on the same piece. This was created

Rookwood Pottery. Albert
Valentien, decorator (attribution).
MONUMENTAL VASE. 1883.
Earthenware, H. 21, Diam. 12".
Mark: *ROOKWOOD* below kiln
mark, *1883*, G, all impressed on
bottom. Museum purchase

*This early vase illustrates the smear
glaze that was used extensively by
Rookwood prior to the development
of Rookwood Standard.*

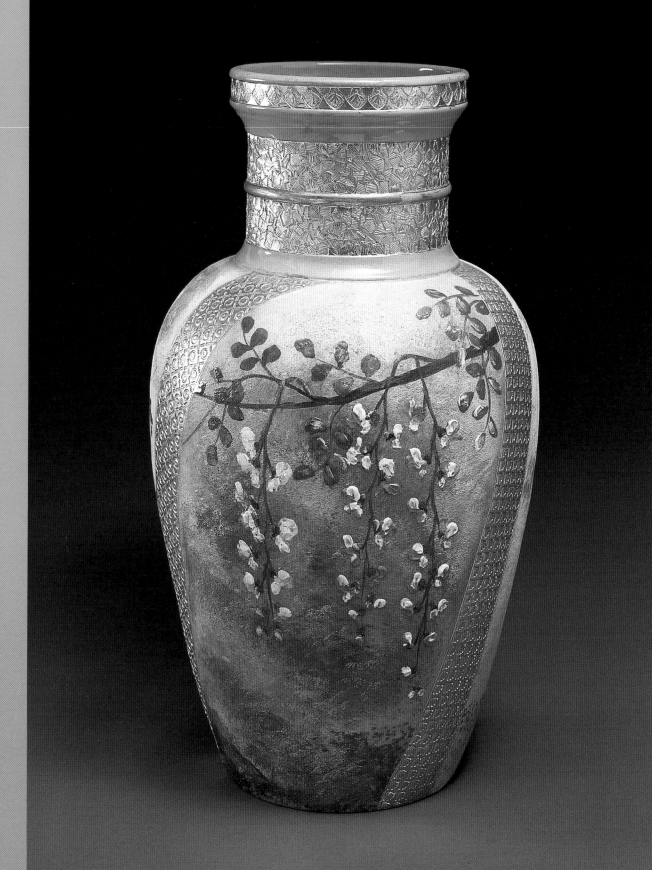

Rookwood Pottery. Anna Marie Bookprinter, decorator. EWER WITH BIRD. 1886. Earthenware, H. 8¼, W. 4⅞". Mark: *ROOK-WOOD/1886/Y* and *29, 9, A.M.B.* all incised on bottom. Gift of Mary and Paul Brandwein

Anna Marie Bookprinter had a fine and delicate touch and worked in both smear glaze wares and Rookwood Standard wares. She was an accomplished sculptor, but her talents were not fully exploited at Rookwood.

Rookwood Pottery. Maria Longworth Nichols, decorator. TANKARD. 1882. Earthenware, H. 8, W. 7". Mark: *ROOKWOOD* stamped on bottom, with *MLN*. Museum purchase

by pressing an incised nail head into the wet clay to create a repeated motif, which was usually then covered with gilding. Sizes ranged from very large vessels up to two feet in height, to smaller table vases from six to eight inches. Albert Valentien was a highly skilled decorator, and many of the finest pieces done in this style were by his hand. He was joined in the decorating department in 1884 by Matthew Daly, who also became one of the pottery's finest painters. He, too, worked in the early smear glaze style, as did Anna Marie Bookprinter, who joined Rookwood in 1884, and who would later marry Valentien.

Another of Maria Longworth Nichols's passions was the japonisme that was sweeping the country (and Europe) at that time. The young matron was so enamored of the style that when she first conceived of establishing a pottery, she tried to convince her father to import an entire Japanese pottery, including workmen, to Cincinnati. Not surprisingly, he refused. The Japanese style, or at least her version of it, pervaded her work, and that of the Rookwood decorators in the early years. Maria must have had access to Japanese pattern books, and to Hokusai's *Manga,* a multivolume sketchbook published by the great Japanese printmaker, for her images are sometimes identical to those found in these publications. Her interest in Japanese imagery is evident in the early decorative motifs of Rookwood. She seemed interested mainly in the more grotesque aspects of japonisme, however, and the early work at Rookwood (including some decorated by Albert Valentien) often exhibits this unusual preference.

In 1884, Rookwood decorator Laura Fry made a discovery that was to revolutionize the art pottery industry and put Rookwood on the map. She found that glaze could be applied to the surface of the vessel with a mouth atomizer, allowing for very even application and for subtle gradations of color. This allowed decorators to create background colors that blended or faded from color to color and from light to dark. Slip decoration could be applied over this, and a gloss glaze added. Thus, what came to be known as Rookwood Standard was born. Rookwood Standard ware is characterized by a dark brown background, sometimes fading to ocher or green, with realistic images of flowers, fruit, animals, or figures applied in slip. There is a slight texture to the surface as a result of the thickness of the brushstrokes of slip. The combination of the dark background, the textured decoration, and the gloss overglaze gives the piece a painterly look and great sense of depth.

This ware was an immediate success, so much so that other potteries immediately set about copying it. Weller produced Louwelsa, Roseville produced Rozane, and Owens produced Utopian, all stepchildren of Rookwood Standard. But none approached the quality of Rookwood wares, particularly in decoration and glazes.

Nichols continued in her dream to bring a Japanese artist to Rookwood, and in 1887 her wishes were fulfilled with the arrival of Kataro Shirayamadani. By this time, Nichols had remarried (she was widowed in 1885) and her interest in the pottery waned to a degree with her relocation to Washington, D.C., with her husband, Bellamy Storer. With her absence, and under the influence of Shirayamadani and William Taylor,

Rookwood Pottery. Kataro Shirayamadani, decorator. JUG WITH EAR OF CORN. 1891. Earthenware, H. 5¼, W. 6". Mark: Rookwood cipher with 5 flames/ *5976/W* stamped on bottom; Shirayamadani's signature incised in Japanese on bottom. Gift of Mary and Paul Brandwein

American motifs were especially popular during this period. This piece illustrates Shirayamadani's consummate skill in underglaze painting.

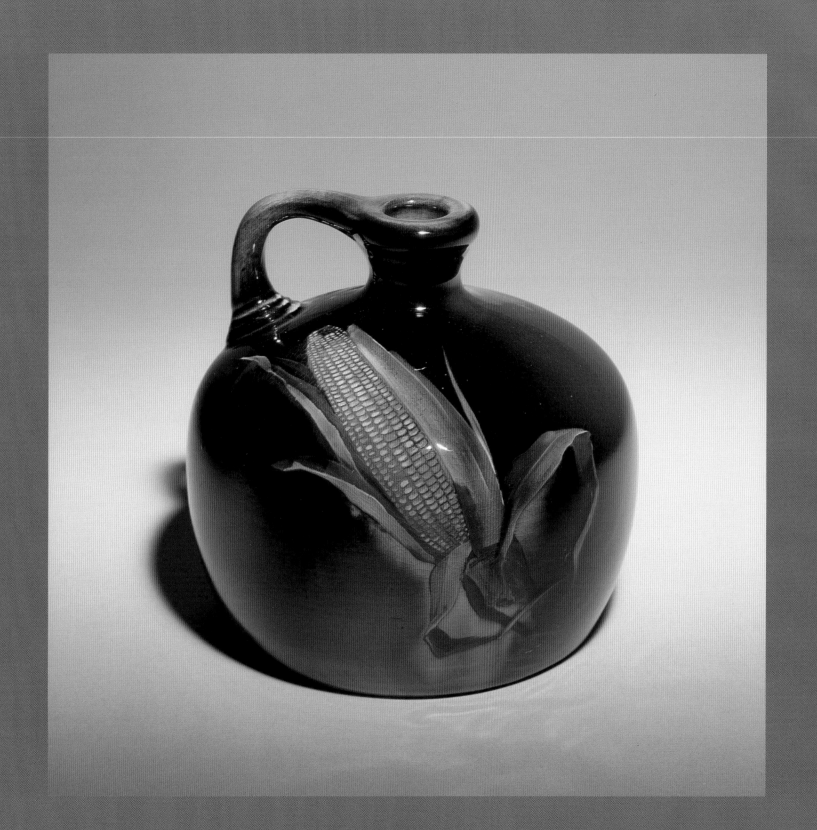

the decorative motifs used at Rookwood moved away from the grotesqueries of the early years toward a more sensitive and refined naturalism. Edward Hurley, Matthew Daly, Elizabeth (Lingenfelter) Lincoln, and Harriet Wilcox produced consistently fine works. Valentien and Shirayamadani had such similar styles and skills that it is difficult to tell their work apart.

Besides his considerable painting talent, Shirayamadani brought a knowledge of Japanese design to Rookwood. Under his influence, Rookwood decoration became more suited to the form upon which it appeared. Classical Western design, with its accent on frontality and contained decoration, gave way to a style in which the decoration enveloped the form, moving around the vessel. The old European fear of the void was overcome, and subtly shaded areas of background were deliberately left devoid of ornamentation, and could be enjoyed for their own qualities. Decoration was illustrative, not interpretive. Blossoms and other objects were presented accurately and for their own sakes, without any accompanying background other than color. The decorators were highly skilled and presented sensitive and poetic renditions of their subject matter. Now there was an artfulness about Rookwood wares that had been missing in the early years. Rookwood achieved a look of its own, and through very high production standards also achieved the highest quality of any American art pottery.

Maria Longworth Storer (as she was now known) retained her interest in Rookwood, but she spent most of her time in Washington, with little actual involvement in the pottery. Rookwood was financially secure now and could survive without her subsidies as a result of the international reputation it had gained through participation in many expositions and exhibitions, where the pottery won a number of accolades and prizes. In 1891, Mrs. Storer gave the pottery to her longtime business manager, William Taylor.[13] A year later, Rookwood moved into new spacious quarters, a Tudor-style building atop a hill overlooking the city of Cincinnati. The complex included three gas-fired bottle kilns, which would speed production considerably.

Standard ware continued in popularity until the turn of the century. It was augmented by Iris, Sea Green, and Aerial Blue, lines that were similar in concept to Standard ware but of different colors. Aerial was produced only briefly, but Iris became one of the pottery's most popular and elegant glazes. It was a piece of Iris ware that won for Rookwood the coveted Grand Prix at the Paris Exposition of 1900. Introduced in 1894, the Iris line has a white body (though sometimes gray or green bodies were also used), and the glaze is colorless and very glassy. This line allowed the decorators greater opportunity in the use of color than they were able to achieve with other lines, especially the Standard ware, and most decoration is subtle and delicate. By 1900, however, tastes had changed, and Rookwood, ever sensitive to the market, developed new glazes and motifs to meet public demands.

The most drastic change in the Rookwood aesthetic came with the introduction of matte glazes. This meant an entire rethinking of traditional Rookwood craftsmanship. Matte glazes are opaque, precluding any use of underglaze decoration. The whole traditional concept of Rookwood production had been based upon

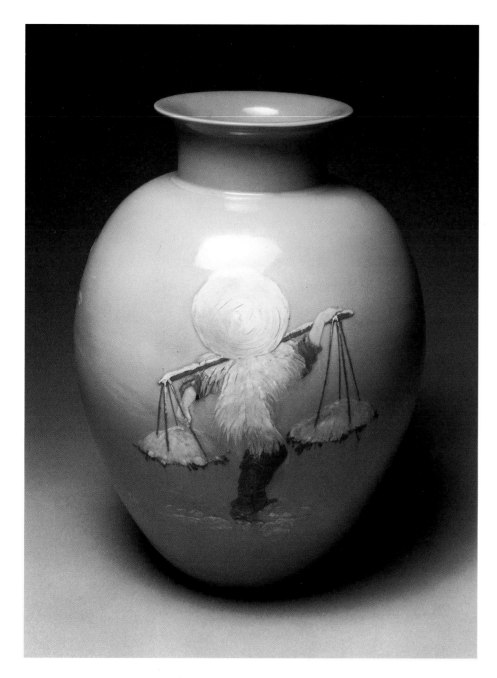

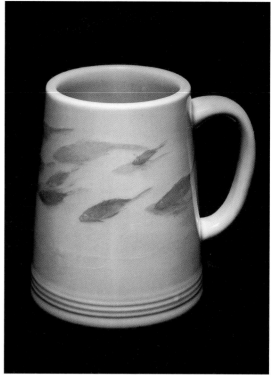

Rookwood Pottery. Edward T. Hurley, decorator. TANKARD. 1903. Stoneware, H. 4½, W. 3⅞". Mark: Rookwood cipher/*587C/ETH* on bottom. Gift of Mary and Paul Brandwein

Fish were a favorite motif at Rookwood, and many of the images were inspired, if not outright copied, from the Manga, *or sketchbook of the Japanese artist Hokusai.*

LEFT: Rookwood Pottery. Matthew Daly, decorator. VASE WITH JAPANESE PEASANT FIGURES. 1889. Earthenware, H. 13½, Diam. 10". Mark: Rookwood cipher, *488, D, G,* and *MAD/L* incised on bottom. Gift of Todd M. Volpe and Beth Cathers, Jordan-Volpe Gallery, New York

The Japanese peasant image came directly from Hokusai's Manga.

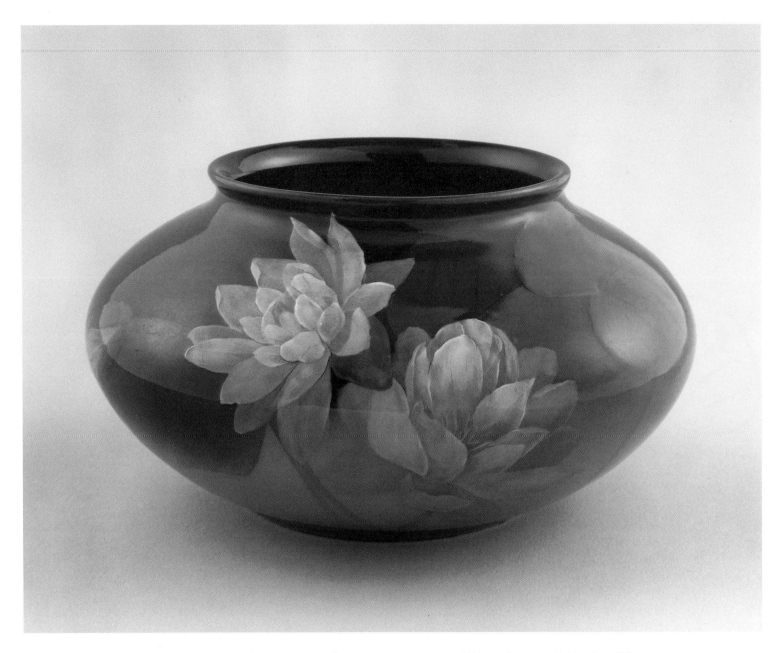

Rookwood Pottery. Elizabeth Lincoln, decorator. WATERLILY VASE. 1900. Earthenware, H. 4½, Diam. 8¼".
Mark: Rookwood cipher and flames, *494, A,* and *LNL* incised on bottom. Gift of Mr. and Mrs. H. Gillis Murray

Rookwood Pottery. Harriet Wilcox, decorator. CHOCOLATE POT. 1889. Earthenware, H. 7, W. 4⅝". Mark: Rookwood cipher with three flames/*251/S/HEW* on bottom. Gift of Mary and Paul Brandwein

The sensitive treatment of the decoration on this small chocolate pot is accented by the nearly monochromatic color scheme which Harriet Wilcox has chosen to use.

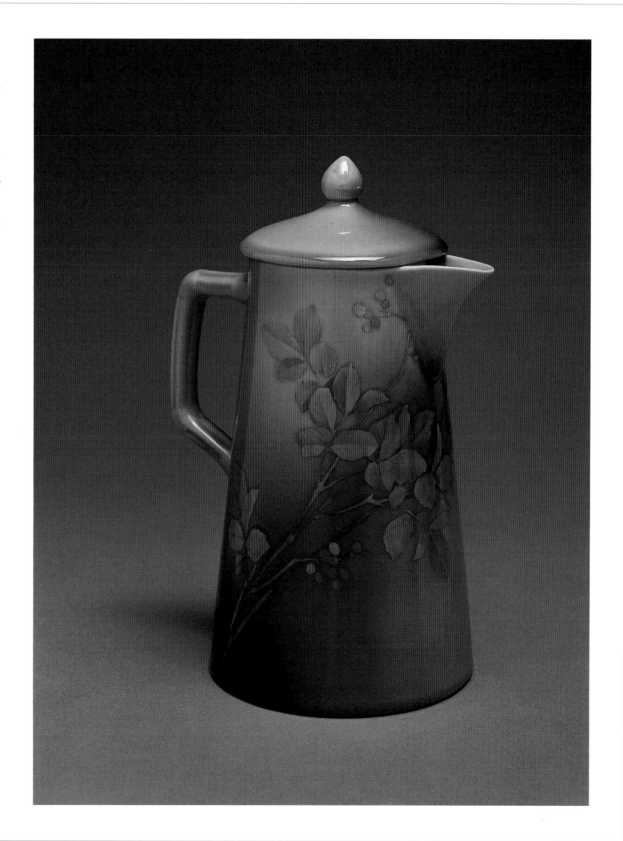

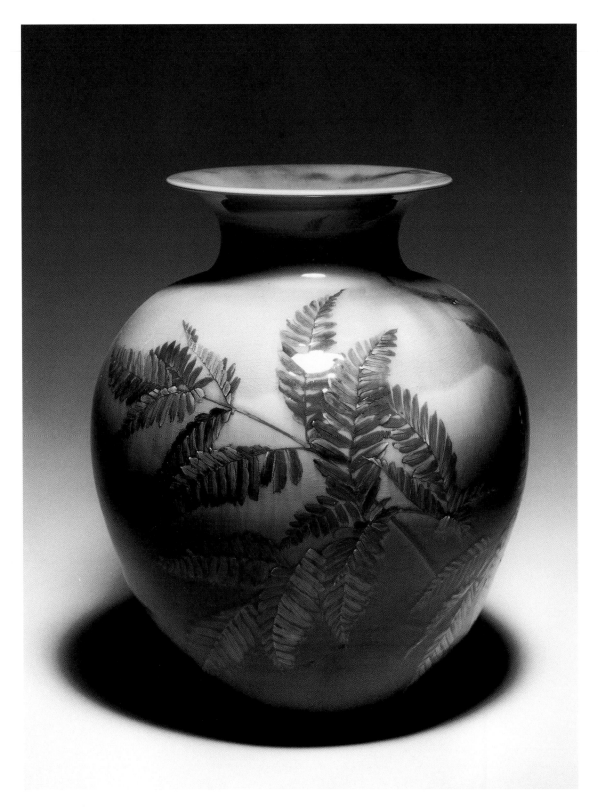

Rookwood Pottery. Kataro Shirayamadani, decorator. VASE WITH FERNS. 1890. Earthenware, H. 10½, Diam. 9¼". Mark: Rookwood cipher with four flames, *8, F,* and *Y* incised. Decorator's signature incised in Japanese. Two stickers read: *C of C 169,* and *Shirayamadani #166,* all on bottom. Museum purchase

Shirayamadani, who worked at the pottery for nearly sixty years, was one of Rookwood's most valuable assets.

OPPOSITE: Rookwood Pottery. Albert Valentien, decorator. HYDRANGEA VASE. 1904. Earthenware, H. 14⅜, Diam. 9½". Mark: Rookwood cipher, *787B,* and *AR VALENTIEN* incised on bottom. Museum purchase with funds from the Dorothy and Robert Riester Ceramic Fund

Valentien and Shirayamadani both developed their painting styles together at Rookwood, making it difficult to tell their work apart.

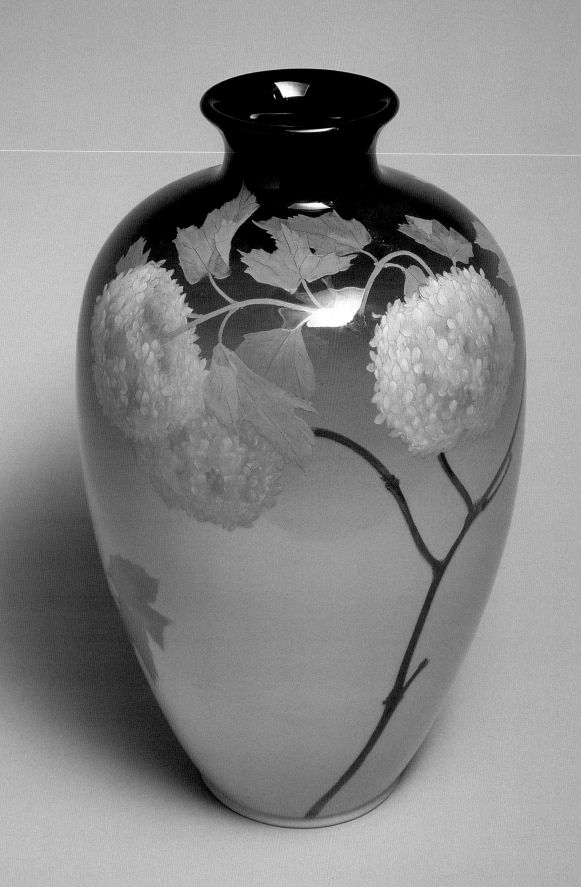

slip-painted decoration under a translucent glossy glaze. This translucent glaze was one of the hallmarks of the pottery: it gave the underlying decoration a wondrous depth, as varnish did to oil paintings. The new matte-glazed ware was a total about-face for the pottery.

Since it bore no painted decoration, the beauty of the matte-glazed piece depended upon the shape of the object and the color and texture of the glaze. Decoration could be added in the form of carving, incising, or modeling. An inlaid glaze decoration was sometimes used, but it was extremely difficult and time-consuming.

The effect of this ware was entirely different from the slip-decorated wares, and was more in keeping with the changes sweeping the American decorative arts during the rise of the Arts and Crafts movement. The matte surfaces blended more readily with the subdued, reserved atmosphere engendered by the more austere interiors appearing at the turn of the century.

There is some question about who developed the first successful matte glazes at Rookwood. In all likelihood it was Artus Van Briggle. Van Briggle had been experimenting with matte glazes at Rookwood before he went to Colorado, and the wares produced at his Van Briggle Pottery there have become synonymous with matte glazes. However, Rookwood has credited Stanley Burt, the superintendent of the pottery, with the discovery.[14]

The matte glazes were produced in a wide variety of colors, and the glaze was handled in several ways. The simplest was the use of matte glazes on incised pieces. Geometric designs were incised on the surfaces of simple forms and the glaze applied overall. This incising could be done from a pattern by relatively unskilled decorators, and took less time than the traditional slip painting on the Standard wares. Thus, pieces could be produced much less expensively and much more quickly. It was but a small step, then, to create molds with the incised designs included, eliminating the decorator altogether.

Simple flat figural decoration could also be accomplished with these new glazes. This resulted in outlined shapes filled in with color, much in the style of the French symbolists and, of course, the Japanese printmakers, whose work was so popular then in the United States. Another inlay technique was also used, whereby a piece was glazed overall, then sections of the glaze were removed, and another color was inlaid in its place, which created a flat, painted effect. This was a difficult technique, and not cost-effective, so few examples were produced.

Vellum was another type of matte glaze used by the pottery. Unlike the other mattes developed at Rookwood, Vellum was translucent. In other words, underlying painted decoration could be seen, but the matte surface imparted a slightly hazy look. It was similar in technique to Rookwood Standard, with slip decoration covered by a glaze, but in this case the glaze was matte. The subject matter was also typically traditional in the manner of the Standard wares.

Soon, however, it was discovered that Vellum was a perfect medium for painting of landscapes, and the

Rookwood Pottery. Grace Young, decorator. IRIS VASE WITH DUTCH FIGURES. 1904. Earthenware, H. 10, Diam. 4¼". Mark: Rookwood cipher with *IV* below. Also *932,* and monogram for Grace Young, all impressed on bottom. Gift of Mary and Paul Brandwein

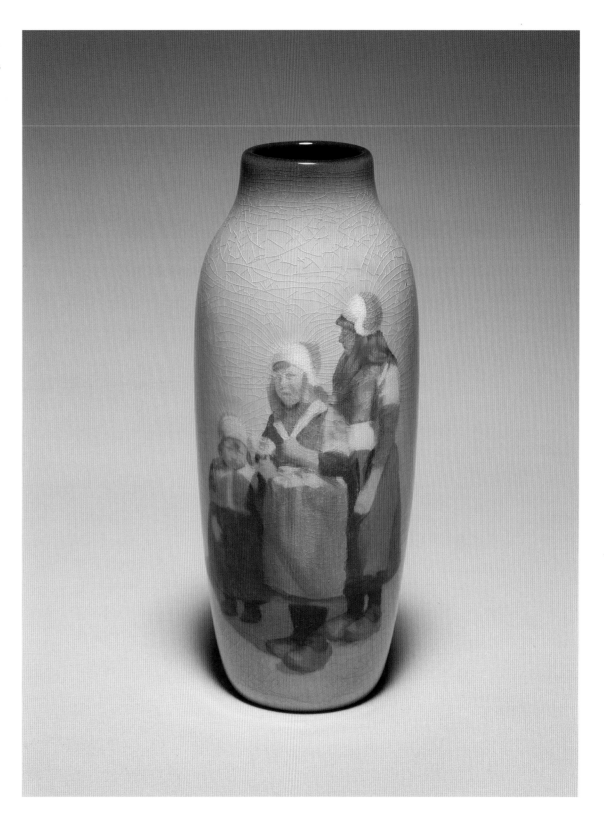

floral subjects became less favored. A Vellum scenic vase of 1907 by Frederick Rothenbusch is held in the Everson collection. Another Vellum piece in the collection, decorated by Sally Coyne, was done in 1916. The winter forest scene is in blues and grays, with the sky of mauve shading to pale rose and yellow. Coyne was a veteran decorator at the pottery, working there from 1892 until 1931. Landscape plaques were also produced, and many are marked with the signature of the decorator. This glaze line proved extremely popular, and continued to be produced by the pottery until 1948.

Rookwood took great pains to provide education, inspiration, and research materials for its decorators. They were, for the most part, formally educated in some phase of art, and in the early years the pottery even sent some of the decorators abroad for continued study. Kataro Shirayamadani was a particularly gifted decorator and one of the greatest assets the pottery had. He came to America as part of the entourage of an entire village sent by the Japanese government to promote interest in Japanese trade. Included in this assemblage of artists and artisans was a group of potters who gave demonstrations in Japanese ceramic techniques. The village had appeared at the Thirteenth Cincinnati Industrial Exposition in 1886. Shirayamadani joined the staff of Rookwood a year later and remained there until his death in 1948, except for a ten-year hiatus during which he returned to Japan. Shirayamadani's work is sensitive and exceptionally delicate. He could paint Japanese dragons as easily as he could paint American ears of corn. After his arrival at the pottery, the application of pattern to the three-dimensional forms took on a different look. In keeping with the Japanese influence, the motifs used now enveloped the forms, following the body of the vessel rather than appearing frontally. The decorators became more sensitive to the three-dimensionality of the form and ceased to regard the vessel as a flat canvas to be painted upon.

The mature work of Albert Valentien (originally spelled Valentine) is often difficult to distinguish from that of Shirayamadani. Valentien came to Rookwood as a young man fresh out of the School of Design in Cincinnati, nineteen years old and relatively inexperienced. His early work reflects the experimentation that was occurring at the pottery in those years, and the japonisme that so fascinated Mrs. Nichols. He seems to have quickly mastered the slip-decorating technique, for there are a number of early pieces by his hand (or attributed to him) that are among the finest produced at the pottery in the years before the development of Standard wares. His *Hydrangea Vase* is a fine example of his mature style, with a delicate touch, elegantly subtle coloring, and a sensitivity to form. Valentien was in charge of the decorating department at Rookwood and one of their ablest decorators. In 1887, he married Anna Marie Bookprinter, another Rookwood decorator, and in 1899 the couple went abroad to study and paint. They left Rookwood in 1905 and in 1908 went to San Diego, having received a commission to paint the wild flowers of California. In 1911, they started their own Valentien Pottery in San Diego, but the pottery was in production for only about a year.

Anna Marie, whose parents had emigrated from Germany, studied at the Cincinnati Art Academy and in Paris (on leave from Rookwood) at the Academy Colorossi and with Rodin, and became influenced by

Rookwood Pottery. VASE WITH DOGWOOD. 1902 or 1906. Earthenware, H. 6¼, Diam. 3¾". Mark: Rookwood cipher (partially illegible) impressed on bottom, with *935 E* below. Also *17/V* incised on bottom. Gift of Mary and Paul Brandwein

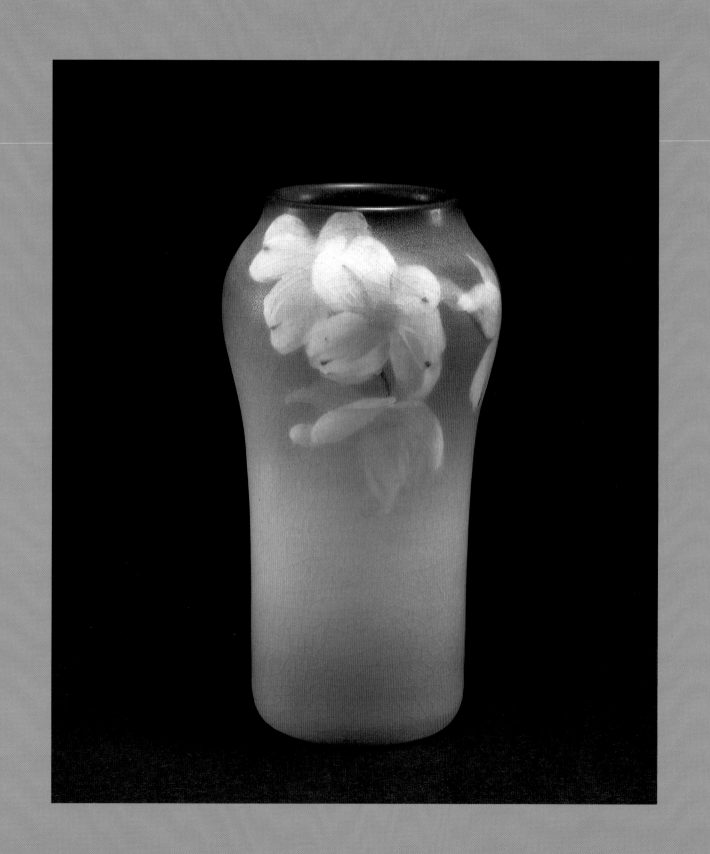

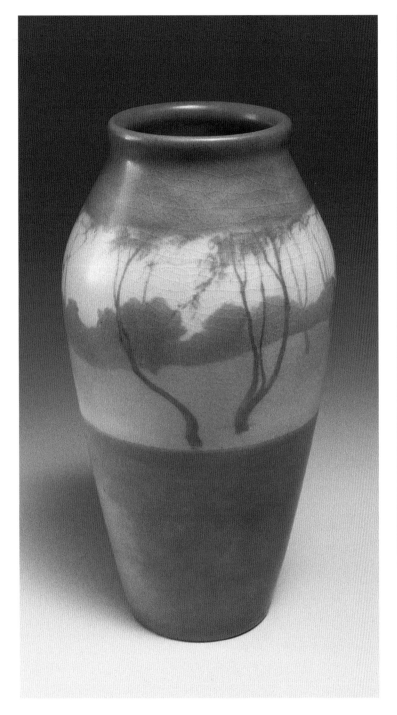

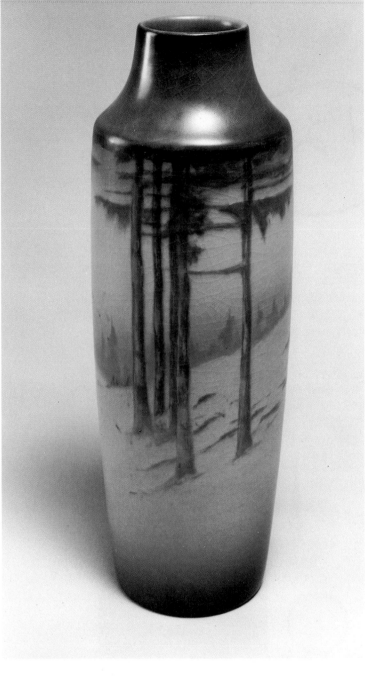

Rookwood Pottery. Frederick Rothenbusch, decorator. SCENIC VASE. 1907.
Earthenware, H. 9¼, Diam. 5¼". Mark: Rookwood cipher/*VII/925CC/A/FR*
on bottom. Museum purchase in memory of Ruth Leonard

The Vellum glaze gives this landscape a slightly hazy atmosphere.

Rookwood Pottery. Sally Coyne, decorator. SCENIC VASE. 1916. Earthenware,
H. 10¼, Diam. 4". Mark: Rookwood cipher/*SVI/941C/V/SEC* on bottom.
Museum purchase in memory of Edward Beadle with funds from friends

Art Nouveau. She was an accomplished sculptor, and tried in vain to interest Rookwood in sculptural decoration on their vessels. She had a gentle and delicate painting style, and worked on both smear-glazed and Standard-glazed vessels. At the ill-fated Valentien Pottery, she produced some elegant and distinctive sculptural pieces that surpass those made by Van Briggle.

Another of Rookwood's most important decorators was Matthew Daly, who joined the establishment in 1882. He, like Albert Valentien, worked in the earlier smear-glaze style, and later in the typical Standard style. He left the pottery in 1903 to work for U.S. Playing Card Company. Daly, Valentien, and William McDonald are often cited as Rookwood's finest decorators. McDonald, trained in Cincinnati, remained at Rookwood throughout his entire career. He was a decorator and a designer, and his monogram is on the pair of rook bookends in the Brandwein Collection.

Laura Fry was probably the most important figure in the history of Rookwood, due to her discovery of the atomizer method of applying background color to the pieces. Fry was from a family of woodcarvers, and studied both in Cincinnati and abroad in England and France. After leaving Rookwood in 1887, she worked for Lonhuda Pottery and then taught at Purdue University for a number of years.

Elizabeth Lincoln was born Elizabeth Lingenfelter, but Anglicized her name during the period of the First World War. She worked at Rookwood for thirty-nine years, decorating both Standard and matte-glazed wares.

Rookwood Pottery. William McDonald, designer. ROOK BOOKENDS. 1920. Porcelain, H. 6½, W. 6½, D. 6" each. Mark: Rookwood cipher/XX74 impressed on bottom. William McDonald's monogram impressed on side near bottom. Gift of Mary and Paul Brandwein

The rook theme is a common motif of Rookwood pottery. Vases, bookends, paperweights, and other items were created around this image.

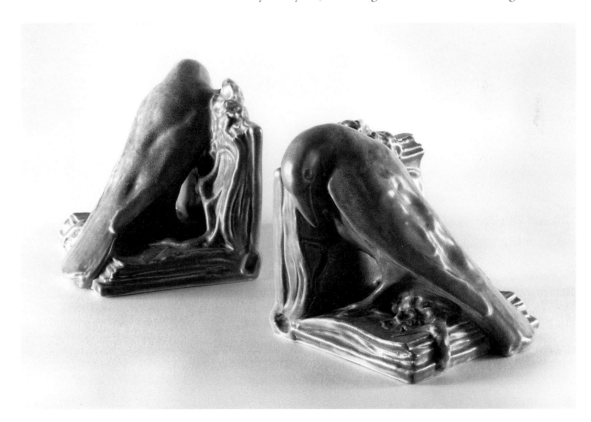

Edward Hurley, who worked at Rookwood from 1896 to 1948, was a nationally known etcher and taught at St. Xavier College. Hurley enjoyed nature, and was particularly adept at Vellum-glazed landscapes. He was also in tune with the changes occurring in American art after the turn of the century, as can be seen in the unusual treatment of the decoration on the *Bird of Paradise Vase*. Hurley also was very much interested in glazing and firing.

Artus Van Briggle was one of Rookwood's most promising decorators with an interest in glazes, and the pottery sent him on an extended study tour of Europe. He was a favorite of Maria Longworth Nichols, and when he had to leave Rookwood because of ill health (he suffered from tuberculosis), she helped to finance the establishment of his own pottery in Colorado.[15]

Rookwood decorators came and went, as at all art potteries. But when decorators left the Cincinnati pottery, they seldom went to other potteries, as did the artists at the Zanesville manufactories. Perhaps working conditions at Rookwood were better than those at other potteries, and the artists who worked there had many "fringe benefits," as they would be called today, including study abroad, company outings and picnics, and a fine library and source materials to work from. There would have been little reason for these artists to seek work elsewhere. Rookwood was also located in Cincinnati, where there were not the large competitive potteries that there were in Zanesville and the surrounding area. There simply were not as many opportunities for ceramic artists in western Ohio as in the eastern part of the state.

As American tastes changed, and the more experienced decorators left the pottery, the look of Rookwood production changed, too. Fewer individually decorated pieces were produced and more and more mass-produced wares were made. Rookwood had to compete with the market, and in the midst of the Depression it became more and more difficult to sell art wares. The financial condition of the pottery worsened, and finally Rookwood declared bankruptcy. The business changed hands several times, with production continuing sporadically. Most of the pieces produced during the later years (production ceased in 1967) are not of the quality usually associated with the Rookwood name.

With the end of the First World War, American art potteries found themselves in a much different commercial and artistic climate. The war years served as a sort of segue between the vessel aesthetic and clay sculpture. Some of the potteries survived, like Rookwood and Roseville, others were merely a shadow of themselves, and many continued for only a short time. The art pottery movement was taking on a different character.

Weller Pottery, Zanesville, Ohio

Samuel A. Weller initiated the art pottery industry in Zanesville, Ohio, a site of many successful potteries. He was already producing decorative ware at his own Weller Pottery when he acquired a partnership in the Lonhuda Pottery in 1894. With the acquisition of Lonhuda, which he moved to the Weller plant, he gained access to Laura Fry's process for applying ground colors with an atomizer (Fry

Rookwood Pottery. Edward T. Hurley, decorator. BIRD OF PARADISE VASE. 1928. Earthenware, H. 14⅝, Diam. 9½". Mark: *E.T.H./* Rookwood cipher/*224 GC* on bottom. Museum purchase

Hurley was well educated and experimented with many different styles and techniques.

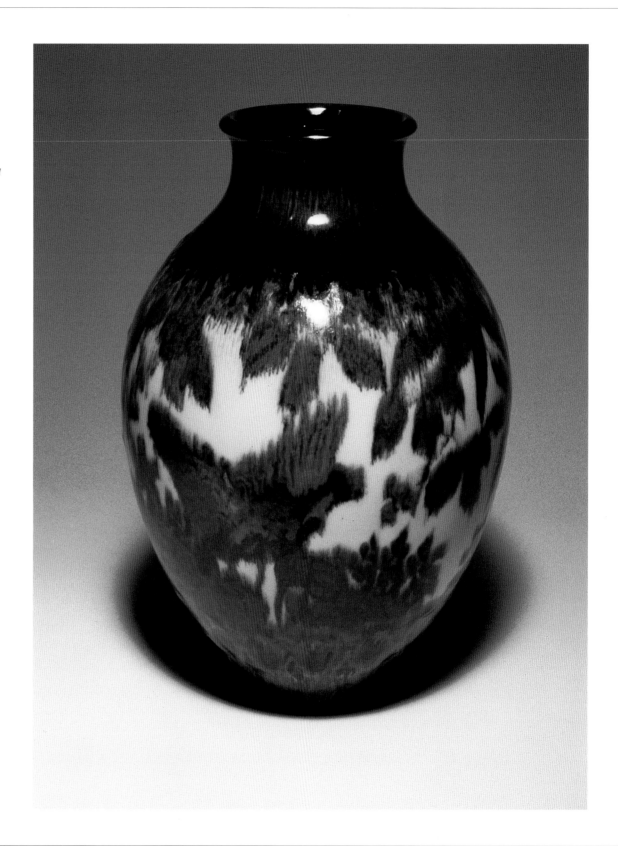

had gone to work for Lonhuda after leaving Rookwood). He then began producing the underglaze decorated ware at Weller. He named his new line Louwelsa, which competed successfully with Rookwood.

The process used at Weller was the same as that used at Rookwood, and the subject matter was also similar. Flowers, fruits, animals, and other natural motifs were used. Weller is also noted for the use of American Indian portraits on the surfaces of its vessels, done in the underglaze slip technique. Weller's Louwelsa only approximated Rookwood Standard, however. While it was very successful commercially and also of a high artistic quality, it could not stand up to a comparison with the same wares produced at Rookwood. The underglaze decoration was not consistently of such high quality, nor was the coloring. The overglaze was not as refractory, as well. But it does remain one of the finest wares of its kind produced during the period.

Being a well-run commercial venture, Weller introduced other lines besides Louwelsa. By 1898 the pottery was also producing Tourada and Dickens' Ware. Dickens' Ware came in three varieties, but that known as II Dickens is the finest and best known. This line is decorated with incised outlines filled with bright colors, usually without modeling, resulting in a flat decorative area within the incised line. This is then covered by a high gloss or a semimatte glaze. The results are attractive, and the subject matter, in many cases, quite charming.

The arrival of Frederick Hurten Rhead in the design department signaled the introduction of other new lines. Jap Birdimal, the most popular, was similar to II Dickens except that instead of incised lines, the lines were produced by outlining the decoration with slip squeezed in a thin line from a bag with a fine tub. Rhead, who was associated with many potteries during his long career, stayed at Weller only a short time, and then moved on.

Probably one of the most important and most successful of the Weller decorators was Jacques Sicard, a Frenchman who arrived at the pottery in 1902. Sicard had worked for many years with Clement Massier at Golfe Juan. The Massiers had produced low-fired ceramics for many years at their pottery in Vallauris, where their ancestors had worked for several centuries. The Massier pottery was noted for its brilliantly colored majolica, flambé glazes, and luster ware. The lusters produced there were new and unusual, and of a very rich color. Sicard had undoubtedly developed his unique palette and luster glaze through his associations with the Massiers. The pottery in Vallauris closed just about the time Sicard came to America, so perhaps this was the reason for his emigration.

Weller Sicard or Sicardo ware, as this particular style came to be known, is one of the most beautiful and highly sought after lines of American art pottery. The forms are usually relatively simple, but the decoration is deeply colored and lustrous. Deep purples, peacock blues, rich reds, and emerald greens combine with a lovely soft luster to create a rich and sensuous surface. The decoration is usually in the Art Nouveau style, with stylized sinuous floral and leaf designs the norm. Most pieces are signed by Sicard, often on the body of the vessel, in a flowing cursive hand.

Sicard was very secretive about his processes, and only allowed his trusted assistant in his studio while

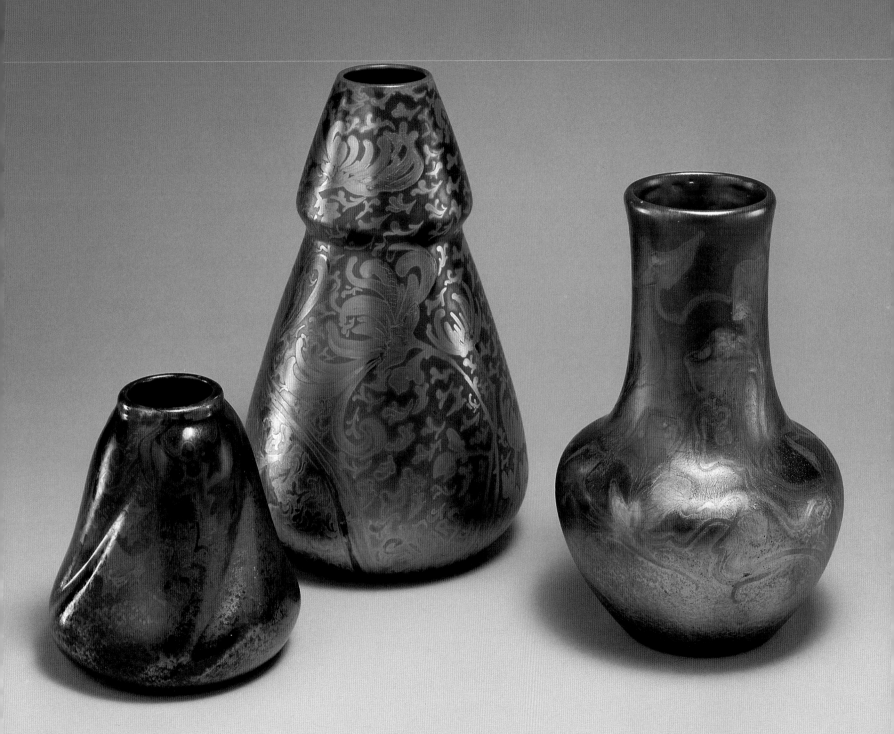

Weller Pottery Co. Hester Pillsbury, decorator. VASE WITH ACORNS. 1896–1924. Earthenware, H. 3, Diam. 5¼".
Mark: *LOUWELSA/1/WELLER/481/6* stamped in blue on bottom; *HP* on body. Gift of Mary and Paul Brandwein

he worked. Perhaps he did not entirely trust Samuel Weller, who had apparently cast aside his original partner, W. A. Long, at Lonhuda once he had learned the process for producing the atomized glaze effect from him. Sicard worked at Weller until 1907, when he returned to France, taking his secrets with him.

Weller also had its resident Japanese potter, Gazo Fujiyama, who had worked in Paris before he came to the United States. Fujiyama has become somewhat of an enigma to historians, for he worked at Roseville and Owens as well as at Weller, and it is often difficult to tell which pottery produced which pieces. At Weller, he designed a line called Fudzi, while at Roseville he produced a line called Fudji, which adds to the confusion.

Probably one of the most talented and best-educated decorators at Weller was Karl Kappes, a native of Zanesville. Kappes attended art school in Cincinnati, and later studied in New York with William Merritt Chase. He went on to Munich to study, and upon his return to Zanesville he gave art lessons and worked at Weller, where he headed the art department. He also worked on the Louwelsa line.

Hester Pillsbury was one of Weller's finest floral painters, though she also did fruits, horses, and birds. The Timberlake sisters, Mae and Sarah, also worked for Weller, decorating various lines such as Hudson, Eocean, and Louwelsa. Mae also decorated Weller art tiles. She was the more talented of the two, and it is said that the Weller supervisors always gave her the largest and most difficult pieces to decorate. She was able to do as many as seven large Hudson vases in a day.

R. G. Turner specialized in portraits at Weller, including a fine Louwelsa vase decorated with a portrait of the famous Nez Perce chief, Joseph. American Indian portraits were popular subjects for many art potteries for a period of about fifteen years, beginning at the turn of the century.

One of several potteries in Zanesville, Weller had keen competition, not only in the marketplace, but also in the hiring of competent help. Roseville and Owens potteries were vying for the same customers and production personnel as Weller. In a pottery town, it is not surprising that workers moved frequently from workplace to workplace. Decorators are the easiest to track from one pottery to another because they signed their work. But chemists, designers, kiln men, and other workers must have moved with the same ease, for the market was good and production was high.

During the golden days at Weller, decorators had extraordinarily good working conditions. The decorating studio had draped windows, and walls hung with paintings, plaques, and flower holders created by the artists.[16] Decorators worked from fresh flowers, illustrations by other artists, or from etchings. Apparently, Weller did not go to the extent that Rookwood did to provide its decorators with inspiration and encouragement, but they must have been well supplied with source materials and they did have a pleasant work place.

Unlike the decorators at Rookwood, who were well educated and highly trained, often at the expense of the pottery itself, only a few of the decorators at Weller had extensive formal art training, and many were trained directly at the pottery itself. Ruth Axline, perhaps the only Weller decorator still alive, has said that at times decorators were brought in off the streets.[17] This would have been in the later years of the pottery, however.

Weller Pottery Co. R. G. Turner, decorator. CHIEF JOSEPH VASE. c. 1904. Earthenware, H. 15½, Diam. 10½". Mark: *Rozane/61/ RPCO/2* impressed on bottom; *RCT* painted in slip under glaze on front, next to portrait; *Chief Jos* in slip under glaze below portrait. Gift of Mary and Paul Brandwein

The Nez Perce Chief Joseph, who had become a symbol of the plight of the Native Americans, was a popular figure at this time. He died in 1904.

OPPOSITE: **Weller Pottery Co. Marie Rauchfuss, decorator. LOUWELSA VASE WITH PORTRAIT OF AN INDIAN. c. 1900–1915. Earthenware, H. 10¼, Diam. 6½". Mark:** *Louwelsa/ Weller/564/0* **impressed on bottom. Gift of Mary and Paul Brandwein**

American Indian images appear frequently on objects decorated under the glaze. There was a fascination for anything having to do with Native Americans during the period, and some potteries, including Weller, produced vessels modeled after early Indian pieces.

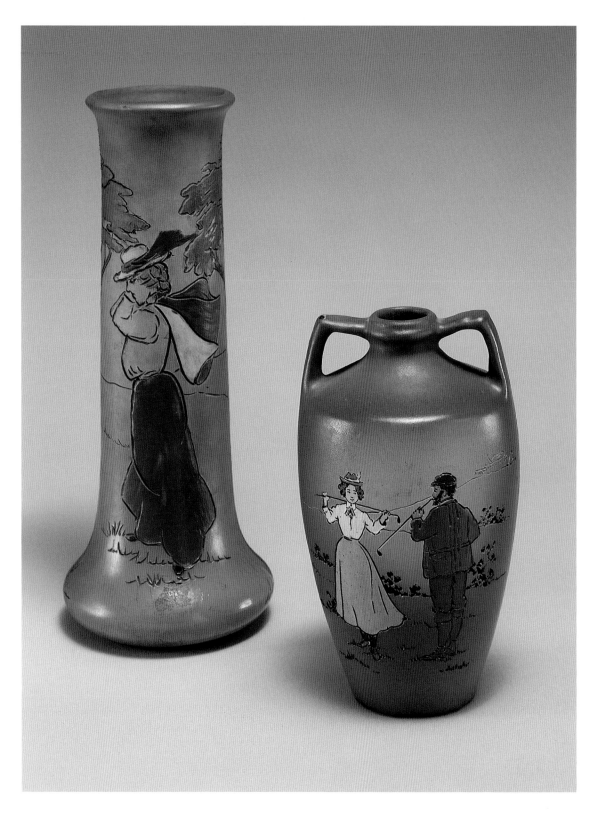

Weller Pottery Co. Charles Babcock Upjohn, designer. DICKENS' WARE VASE WITH FIGURE OF A WOMAN. c. 1900. Earthenware, H. 10, Diam. 4". Mark: *DICKENSWARE/WELLER* impressed on bottom. Gift of Mary and Paul Brandwein

Weller Pottery Co. DICKENS' WARE VASE WITH GOLFERS. c. 1900. Earthenware, H. 6¼, Diam. 4". Mark: *Dickensware Weller/X225/C3* on bottom. Gift of Mary and Paul Brandwein

Like many of the other art potteries, which after all were established as commercial ventures, Weller turned more and more to mechanization and mass production. Hand work was costly, and by the beginning of the First World War, production of hand-decorated art ware had all but ceased. Among the last lines to be produced was LaSa, a luster ware decorated with landscape motifs in warm tones of brown, black, ocher, and deep orange. This was designed by John Lessell, the art director at Weller from 1920 until 1924.

Sam Weller died in 1925, and the pottery continued for a number of years until it, too, fell victim of the Depression and the declining interest in art pottery among the buying public. Pottery production was discontinued in 1948, and in 1949 the S. A. Weller Company was dissolved.

Weller was conceived and established with much different ends in mind than was Rookwood. Rookwood was not, in the beginning, a commercial venture, but rather an artistic adventure begun by a wealthy woman that evolved into an establishment dedicated to artistic achievement and which produced the finest art pottery in this country. While Rookwood became a flourishing business, its sole raison d'être was not profit, at least in the early years. From the beginning, Weller was established with that in mind.

Although the pottery was not on the cutting edge of development, either technically or artistically, Weller did produce some of the finest art pottery of the era. Like most of the other potteries of the time, Weller looked to Rookwood for leadership. Rookwood, Roseville, and Owen were its biggest competitors,

Weller Pottery Co. Coppertone Fan Vase with Frogs. c. 1925–30. Earthenware, H. 8, W. 9½, D. 3½". Mark: *WELLER POTTERY* and cipher stamped on bottom. Gift of Mary and Paul Brandwein

Weller Pottery Co. John Lessell, designer. LASA VASE. 1920–24. Earthenware, H. 13, Diam. 4½". Mark: *Weller-Lasa* on base. Gift of Mary and Paul Brandwein

OPPOSITE, LEFT: Weller Pottery Co. LOUWELSA EWER. 1896–1924. Earthenware, H. 8¾, Diam. 4¾". Mark: *LOUWELSA/WELLER/603* impressed on bottom. Gift of Mary and Paul Brandwein

OPPOSITE, RIGHT: Weller Pottery Co. HUDSON VASE WITH IRISES. 1920–35. Earthenware, H. 8½, Diam. 3". Mark: *WELLER* impressed on bottom. Gift of Mary and Paul Brandwein

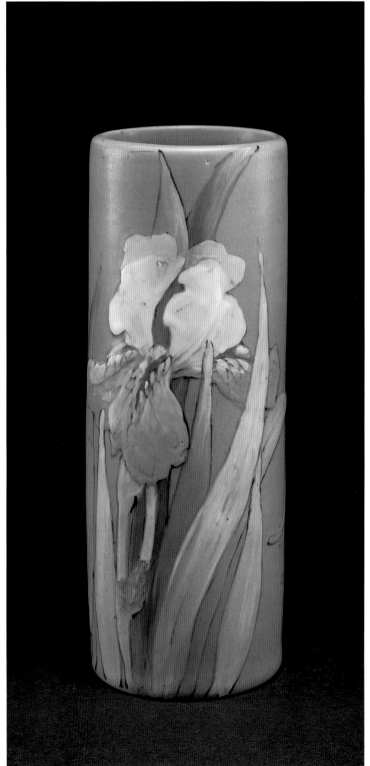

and it often imitated their wares in order to keep in the market. Weller, did, however, produce some exceptionally fine wares of their own. Sicard ware was inimitable, and their LaSa was unique, as well. Louwelsa is a fine version of Rookwood Standard, but without the depth and subtleties of color and design. The Brandwein collection has a rare and lovely piece of deep blue Louwelsa. Dickens' Ware was a good line, and there are many superb pieces of Hudson. And, of course, Jap Birdimal is a handsome example of their production.

Roseville Pottery, Zanesville, Ohio
The name Roseville is most appropriate for this pottery, established by George F. Young, because its wares were decorated to a great extent with floral motifs of some kind. The manufactory originated in Roseville, Ohio (hence its name), but moved to Zanesville six years later in 1898. In 1900 it began to make art pottery, and by 1905 it employed 350 people. One of the secrets of Roseville's success was that it produced a wide range of wares priced from very expensive hand-decorated pieces to commercial dinnerware and inexpensive premiums for the A & P company. It became the most productive and long-lived art pottery in the country.

Roseville not only competed with the dozen or so potteries in or near Zanesville (including Weller and Owen), but also with Rookwood and the myriad smaller establishments that flourished, some only briefly, during the period. The pottery's output was prodigious, with one or more new lines added every year. Once a line was successful, it continued in production as long as there was a market for it. In Zanesville, the pottery operated in two plants, with art ware being produced at the pottery on Linden Avenue and cooking ware at the Muskingum Avenue plant. Art pottery was never made at the Roseville location.

Like Weller, Roseville Pottery was, from the beginning, a business venture. Young was touted in the local press as an enterprising and able manufacturer and a good businessman.[18] The establishment of the pottery was seen as a boon for the city because of the number of people to be employed. When the Linden Avenue plant was being remodeled to produce art pottery, the latest machinery was installed, making the pottery one of the best equipped in the country.

Taking note of the success of Rookwood, Young first introduced the Rozane line, which was an imitation of Rookwood Standard. It was similarly decorated, usually with floral motifs, slip painted under the glaze. Other subjects were added, based on motifs from nature, portraits, or animal studies. The dark browns and ochers gave the ware the look of Rookwood Standard. As Rookwood added lines such as Iris and Vellum, Roseville responded with their own Rozane Light and several lines with matte glazes. Rozane was soon designated Rozane Royal, and the name Rozane was expanded to include other hand-decorated pieces, not just those in the manner of Rookwood Standard.

Rookwood focused on hand decoration, and quality was foremost in their production. Roseville, however, was more profit motivated, and used less handwork, allowing them to sell their wares at lower prices. The smaller Rozane vases sold for as little as five dollars each. Rookwood pieces sold for much more. This

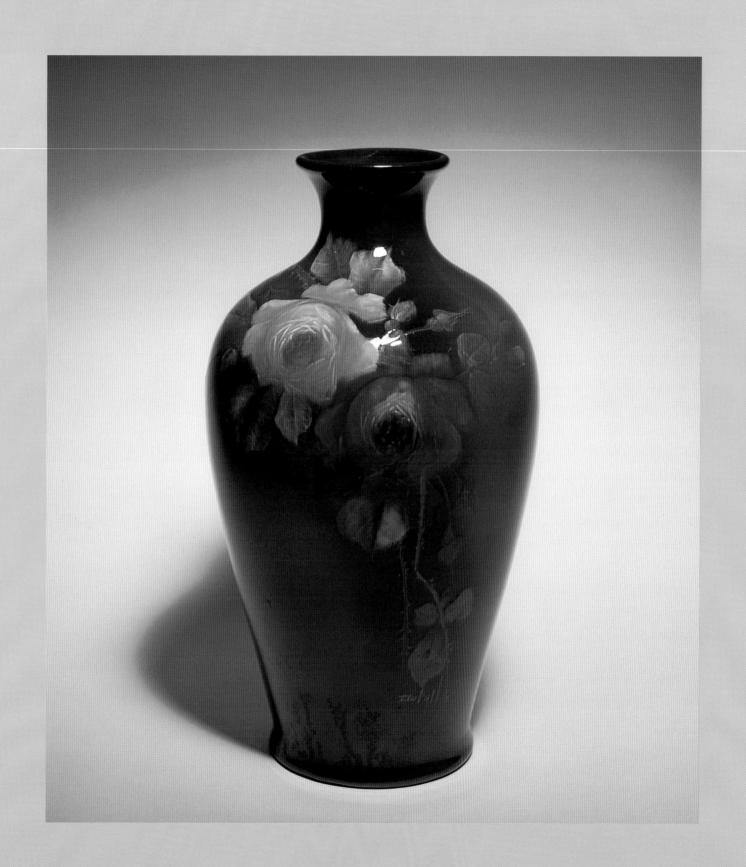

put Roseville pieces within reach of the average worker, although a little high for the laboring class. The average wage for a Roseville worker in 1920 was about three and a half dollars a day, with kiln men earning twenty-four dollars per week.

Perhaps because Roseville was concerned with economical production, there is a very basic difference between the look of Roseville wares and other American art pottery. From the beginning, even with the Rozane wares, shape was of primary importance. If a shape is interesting in itself, there is less need for decoration, particularly the expensive hand decoration typical of Rozane Royal. Upon examining the production of the pottery, one realizes that, early on, Roseville objects were given unusual shapes and appendages, particularly handles. While the pottery did produce the usual simple ovoid and bulbous Beaux-Arts shapes, there was also, from the beginning, a profusion of attenuated necks, ruffled rims, sloping sides, and, most importantly, a diverse array of handles. Even in the earliest Rozane ware, shape was of primary importance, perhaps because Roseville did not have the advantage of having highly educated and talented decorators such as at Rookwood. The accent on shape would also give Roseville a distinctive quality in a market filled with Rookwood look-alikes. This accent on shape became even more pronounced as the years went by.

Rozane Royal Light and Azurean, a blue version of Rozane, were produced to compete with Rookwood's Iris and Weller's Aeocean. These pieces are typically Beaux-Arts in shape and decoration, with more flamboyance than one finds in the objects produced by Roseville's competitors. The year 1904 was a busy one for the pottery. John Herold created Rozane Mara to compete with Weller's Sicardo, and Christian Nielson created Rozane Egypto, a green matte glazed ware supposedly in the style of old Egyptian pottery, but actually a rather eclectic line. That year Roseville also won first prize at the St. Louis Exposition with its high gloss *sang de boeuf* line called Mongol.

In keeping with the practices at Rookwood and Weller, Roseville also hired the requisite Japanese potter, the peripatetic Gazo Fujiyama, who also worked for Weller, and later at a pottery in Monica, Pennsylvania. Gazo designed Woodland and Fudji for Roseville, neither of which are particularly Eastern in style. Gazo had spent many years in the West by this time, including ten years in Paris, and his work speaks more of Art Nouveau than of Japanese design.

Roseville was given a boost as far as design and production were concerned when Frederick Hurten Rhead joined the staff as art director in 1904. Rhead had worked at Weller for a short time before transferring to Roseville. Though his tenure there was relatively short (he left in 1908), Rhead contributed a great deal to the firm. Under Rhead, the focus of decoration at Roseville changed from that of viewing the surface as a canvas to be painted, to textured decoration which emphasized the three-dimensional form.

Under Rhead's direction, the pottery introduced Rozane Royal Light, Mara, Aztec, Della Robbia, Chrystalis, Olympic, Egypt, and a number of other lines. Rhead streamlined the shapes used by the pottery, eliminating many of the more extreme shapes and reducing the ruffles and meandering handles. Della Robbia is

one of the most famous of his lines, with the decoration carved into the moist clay. The background clay was cut away, revealing an underlying layer of color. Other sections of color could be obtained by adding areas of slip. Della Robbia was relatively time-consuming to produce and was never made in a large quantity.

When Frederick Rhead left the company, he was replaced by his brother Harry. In 1914 Harry introduced Pauleo, a prestige line that was produced in two basic glazes: luster and marbleized. There were eighteen shapes in all. This line proved to be very popular, though it was quite expensive. Pauleo was only sold in Roseville's New York Fifth Avenue shop, and some pieces were priced as high as five hundred dollars, a large sum in those days. The Brandwein Collection has a fine piece of marbleized Pauleo with a deep burgundy glaze.

Harry Rhead was also responsible for the introduction of Donatello, one of the most popular and financially successful of all of Roseville's lines. Inspired by the sculpture of the Italian Renaissance artist of the same name, Donatello was produced in a wide variety of shapes for over ten years. The shapes are classic, with fluting, and a frieze of chubby cherubs in true Renaissance style who dance, play instruments, paint, read, or engage in playful romantic pursuits. Because it was produced over such a long period, there are some pieces

Roseville Pottery Co. BANEDA
VASE. 1933. Earthenware, H. 12½,
Diam. 6½". Mark: none. Gift of
Mary and Paul Brandwein

**Roseville Pottery Co. SNOWBERRY
BUD VASE. 1946. Earthenware,
H. 7¼, W. 4". Mark:** *Roseville/U.S.A./
IVI-7* **in relief on bottom. Gift of
Mary and Paul Brandwein**

*This delicate little bud vase illustrates
how lovely and graceful the later molded
wares could be.*

Roseville Pottery Co. FUTURA HANDLED VASE. 1928. Earthenware. H. 9, Diam. 5¼". Mark: none. Gift of Mary and Paul Brandwein

Futura was Roseville's Art Deco line, although many pieces listed as Futura are quite unlike this style. In fact, there did not seem to be any true theme for the line, but Art Deco objects prevail, with colors as varied as bright pink, green, dark blue, and yellow.

Roseville Pottery Co. AZTEC VASE. 1915. Earthenware, H. 8¼, Diam. 4½". Mark: C on body near bottom. Gift of Mary and Paul Brandwein

Aztec was decorated with a flowing linear design created by the use of a bag that trailed slip on the surface of the vessel.

Roseville Pottery Co. EGYPTO COMPOTE. 1904. Earthenware, H. 9¾, Diam. 6". Mark: none. Gift of Mary and Paul Brandwein

Though called Egypto, there are more medieval or Art Nouveau elements in this line than Egyptian.

Roseville Pottery Co. DONATELLO BOWL. 1915. Earthenware, H. 4, Diam. 5".
Mark: Sticker on bottom reads *Roseville Pottery Exhibition*. Gift of Mary and Paul Brandwein

from worn molds that have poor definition, and while a good piece of Donatello is quite fine, there are also pieces of less desirable quality around. It should be pointed out, in all fairness, that Roseville was very concerned with quality control, and it may well be that some of these "mushy" pieces were seconds, and were sold as such at the time.

Donatello pieces were moldmade, and, required some handwork. The colors are traditionally green, cream, and brown. The decorators dipped the pieces in a cream glaze, and sprayed the green and brown areas, which were then wiped off with a sponge to create highlighting. There are also some pieces entirely glazed with cream, but these are considered part of the Ivory line. With the wild success of Donatello, Weller responded with a similar line of cherubs and fluting which they named Fairfield.

This combination of mass production and hand decoration proved to be the norm in American art potteries after the initial phase of the movement. Most manufactories soon realized that hand decoration was not a profitable technique, and profit was, by necessity, always a primary consideration. Even Rookwood had to be self-sustaining after the departure of Maria Longworth Storer, with her generous purse. As a result, completely handcrafted wares became rarer and rarer; eventually any amount of hand work was a decided impediment in the adoption of a new line. After 1919, Roseville abandoned all freehand decoration and concentrated on molded wares.[19] Not only were these cheaper and quicker to produce, the Roseville roster of talented decorators had been depleted by illness (the flu epidemic hit about this time), the war, and by the usual causes of attrition. The art directors tried to appeal to a variety of tastes, and this new approach to production gave them much more freedom to expand the types of wares offered to a broad public.

The new art pottery lines that replaced the hand-decorated wares were mold-made with embossed designs. As a result, there was a distinct difference in the look of the wares produced, and this difference was disparate enough that, with it, Roseville acquired what has now become recognized as its own distinctive look. Design played a most important role in the concept of the pottery. No longer constrained by the potter's wheel, shapes became even more distinctive and, in some instances, quite unique. They could be angular or organic, simple or complex. They could be traditional, or could adopt the Art Deco spirit of the times. Designers again sharpened their focus on handles, one aspect of design that was traditional with Roseville wares. Handles became attenuated, graceful, exaggerated, pointed, rounded, distorted, all by turns. Backgrounds might be smooth or textured, with plain or blended colors. Glazes were almost always matte, with gentle (and occasionally not so gentle) coloration.

However, the one thing that became synonymous with Roseville was the use of floral motifs. Over the years, hundreds of types of flowers blossomed from the designers' tables, creating an entire clay garden in salesrooms across the country. The first line of molded wares with matte glaze using a floral motif was First Dogwood, designed by Frank Ferrell. This was followed by two new designs a year, including Morning Glory, Water Lily, Freesia, Cosmos, Peony, and White Rose. One of these, Pine Cone, proved to be the most popu-

Roseville Pottery Co. FALLINE
VASE. 1933. Earthenware, H. 7½,
Diam. 5½". Mark: Roseville
Pottery silver sticker (original)
affixed to bottom. Gift of Mary
and Paul Brandwein

Roseville Pottery Co.
ROSECRAFT HEXAGON VASE.
1920. Earthenware, H. 6, W. 4".
Mark: *V* within *R* stamped on
bottom. Gift of Mary and Paul
Brandwein

Roseville Pottery Co. WINDSOR
VASE. 1931. Earthenware, H. 6¼,
Diam. 4½". Mark: none. Gift of
Mary and Paul Brandwein

Roseville Pottery Co. Group of Handled Vases

LEFT TO RIGHT, FRONT ROW:
MONTICELLO. 1931. H. 6½"; IXIA.
1930s. H. 10". SILHOUETTE. 1952.
H. 10½"; BITTERSWEET. 1940.
H. 6½"; FUSCHIA. 1939. H. 8½"

LEFT TO RIGHT, BACK ROW:
MAGNOLIA. 1940s. H. 10";
MING TREE. 1947. H. 12½";
ZEPHYR LILY. 1940s. H. 11";
WATER LILY. 1940s. H. 8½"

RIGHT CENTER:
DONATELLO. 1915.
H. 9". Gifts of Mary and Paul
Brandwein

*Handles of various design have become
a trademark of Roseville. The accent on
form allowed for less hand decoration,
which was much more expensive to
produce.*

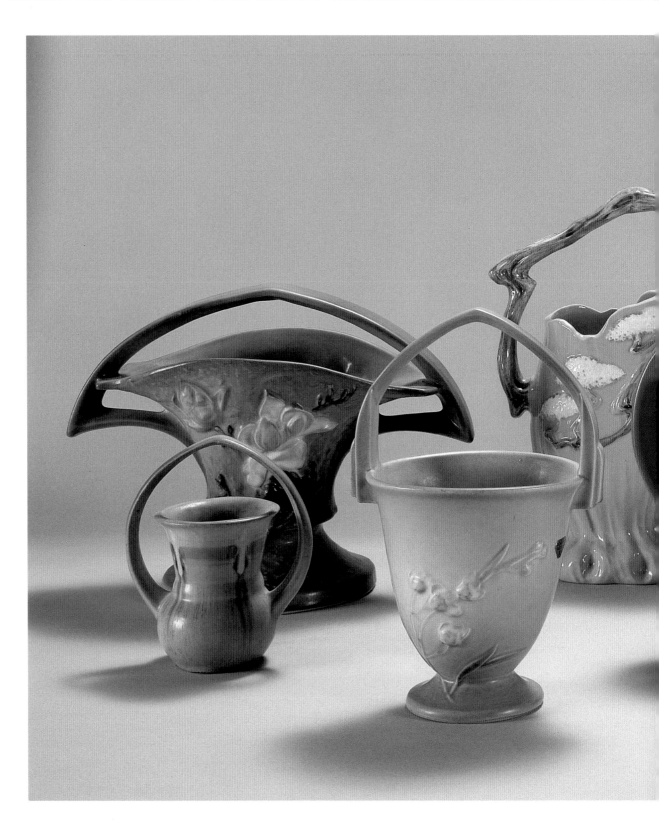

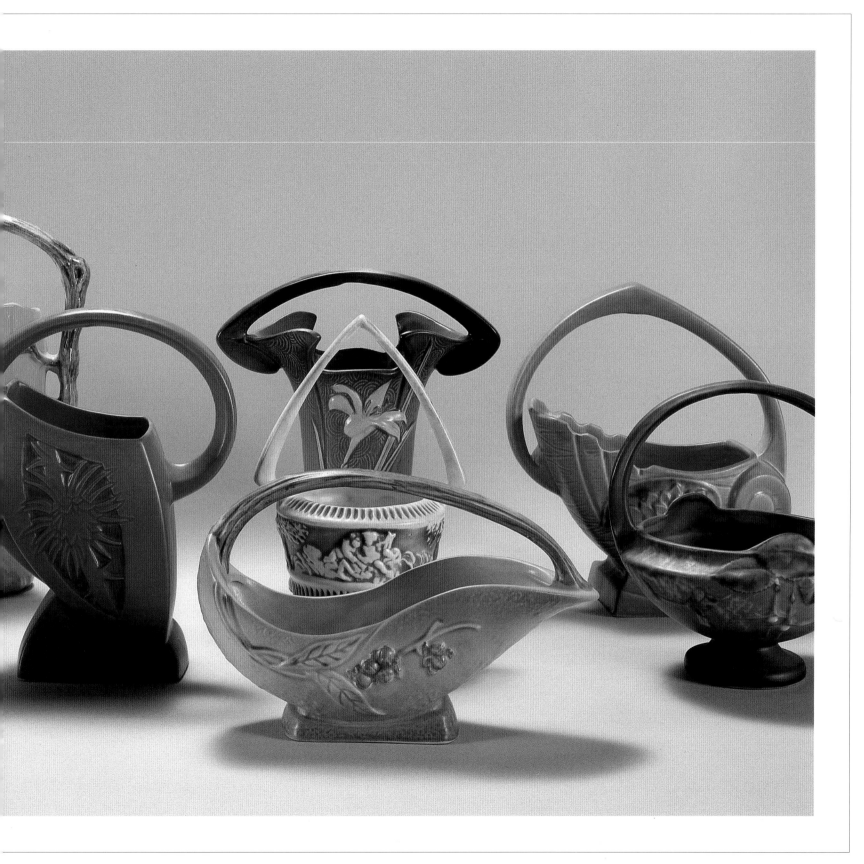

lar line ever produced by the company, and remained in production for fifteen years, from 1935 to 1950. This motif consisted of a pinecone or a cluster of two pinecones placed near the edge of the shape, with tufts of pine needles sweeping gracefully downward on each side. Sometimes the motif included a branch which often became a handle. The sweep of the pine needles creates a frame around the central area of the form which remains undecorated. This is a very Japanese-like technique, and illustrates the lingering influences from the Far East that had permeated Western design during the late 1800s. Pine Cone was produced in many shapes, from large pedestals and jardinières to pitchers, bud vases, baskets, floor vases, wall pockets, and candleholders. It was produced in four colors: green, blue, ocher, and, rarely, pink. It delighted the public, and ultimately saved the pottery, because by 1935 the pottery desperately needed a boost in sales. They definitely got it with Pine Cone.

Another important floral line was Sunflower. The sunflower had been a popular subject for artists during the Aesthetic and the Arts and Crafts periods. Roseville revived it in 1930 and created a small but very lovely line of simple shapes decorated with a repetitive design of sunflowers, leaves, and stems. Like Pine Cone, it appeared on vases, jardinières and pedestals, wall pockets, and candlesticks. Recently, Sunflower has again become extremely popular with collectors.

Futura was introduced about 1924. This line includes a wide variety of shapes and decoration, so much so that one wonders at the sense of order the pottery had (or did not have) in the creation of its separate lines. However, the name Futura now inevitably means the Art Deco objects produced under that name by the pottery. These are wonderfully innovative and energetic pieces, in typical Art Deco color combinations (pink and green, or deep blue and yellow, among others). The shapes are streamlined, but also may be rather complex, as in the space age–looking candlesticks. It is a delightful collection, which has retained its appeal three-quarters of a century later.

The Cherry Blossom line of 1932 also reflects the Japanese influence on American pottery that continued long after the initial mania had waned. The branch of blossoms that swings around the shoulder of the vases and other vessels in this line are very much in the mode of Japanese design, asymmetrical, diagonal, and concentrated. The fluting on the lower areas of the vessels is of Western derivation, but the meandering branches that cascade over it are Japanese-like. Vestiges of the Japanese influence are apparent in very subtle ways throughout the works of Roseville, particularly in the floral designs where blossoms cascade or entwine about the forms, or where negative areas are emphasized, as in the Pine Cone group. Actually, considering the range of output of this pottery, it is surprising to find so few references to the Japanese style.

Frank Ferrell became art director in 1918, replacing Harry Rhead. Ferrell was responsible for the production of the typical Roseville wares, and he remained with the pottery until 1954. Ferrella, one of Roseville's better lines, was named for him. Ferrella, produced in 1931, had unusual but elegant shapes, and a lovely mottled glaze. An incised decoration of a seashell-like motif surrounds the necks and feet of the

Roseville Pottery Co. PINE CONE VASE, 1931. Earthenware, H. 13, W. 12½, D. 2". Mark: *Roseville/805-12"* **impressed on bottom. Gift of Mary and Paul Brandwein**

In its later years of production, Roseville's Pine Cone line was among the most successful. The influence of Japanese design is apparent in the graceful, downward arches created by the pine needles.

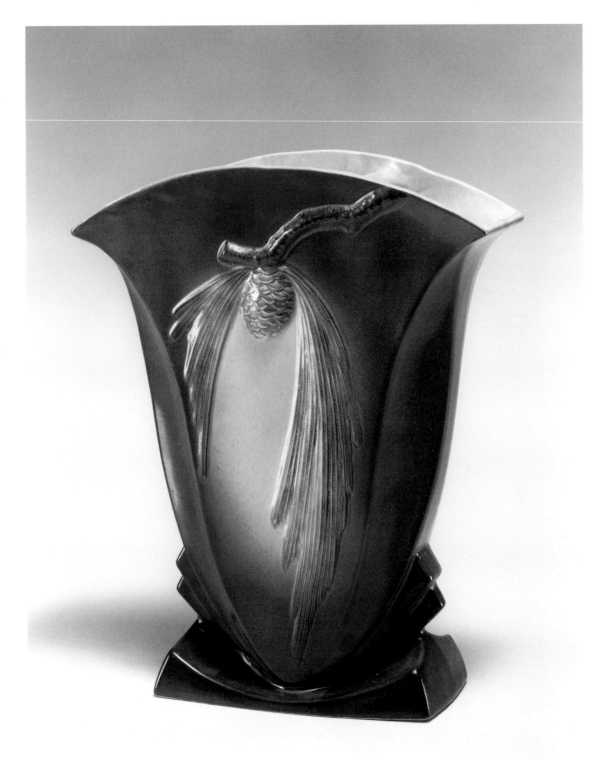

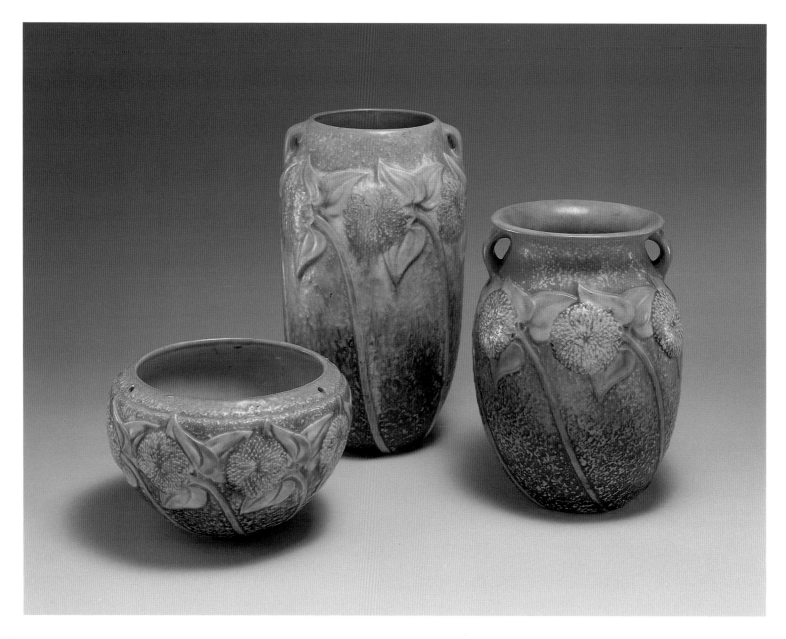

LEFT TO RIGHT: **Roseville Pottery Co.** SUNFLOWER HANGING BASKET, 1930. Earthenware, H. 4½, Diam. 7¼". Mark: none. SUNFLOWER VASE. 1930. Earthenware, H. 8, Diam. 6¼". Mark: none. SUNFLOWER VASE. 1930. Earthenware, H. 10½, Diam. 6½". Mark: none. Gifts of Mary and Paul Brandwein

The sunflower was a favorite motif during the Aesthetic and the Arts and Crafts periods, and appears on furniture, bookbindings, embroideries, and wallpaper, as well as on ceramics.

OPPOSITE: **Roseville Pottery Co.** CHERRY BLOSSOM VASE. 1932. Earthenware, H. 12¼, Diam. 6¼".
Mark: silver Roseville Pottery sticker on bottom. Gift of Mary and Paul Brandwein

Another example of the lingering influence of Japan. Even the cherry blossom itself and cascading branches recall the Far East.

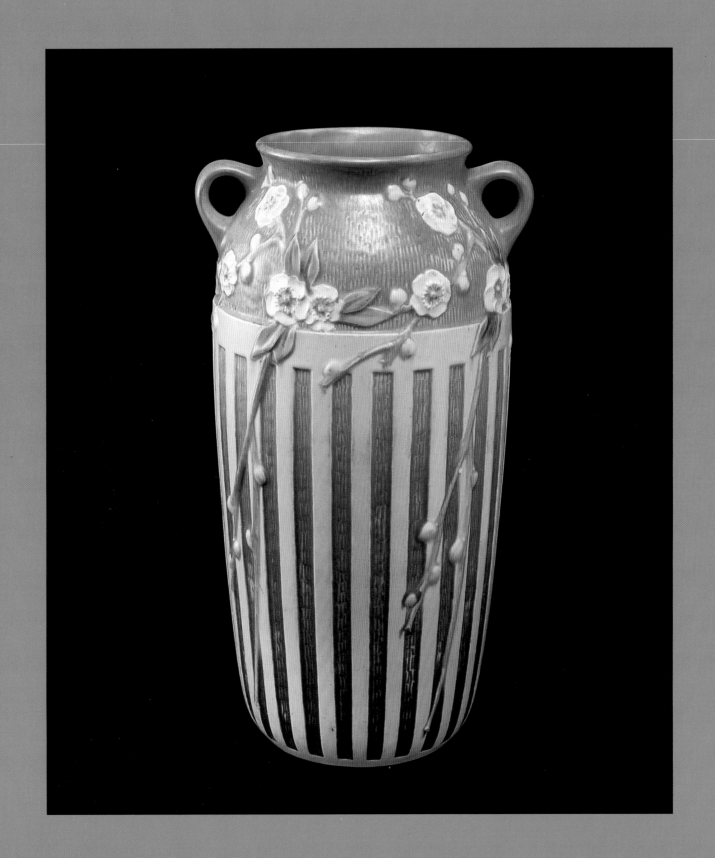

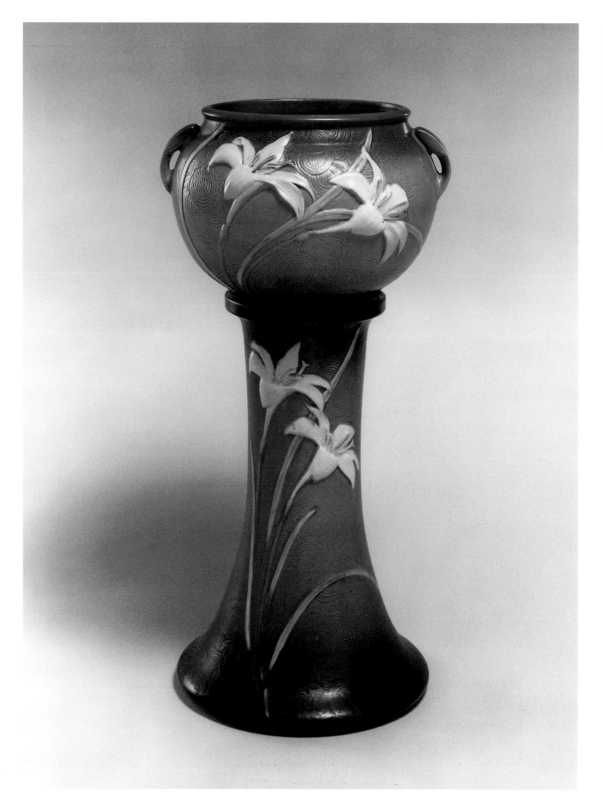

Roseville Pottery Co. ZEPHYR
LILY JARDINIERE AND PEDESTAL.
1946. Earthenware; pedestal:
H. 16¾, Diam. 11"; jardiniere:
H. 8½, W. 13". Mark: pedestal:
USA in relief on top, jardiniere:
Roseville/USA/671–8" in relief on
bottom. Gift of Mary and Paul
Brandwein

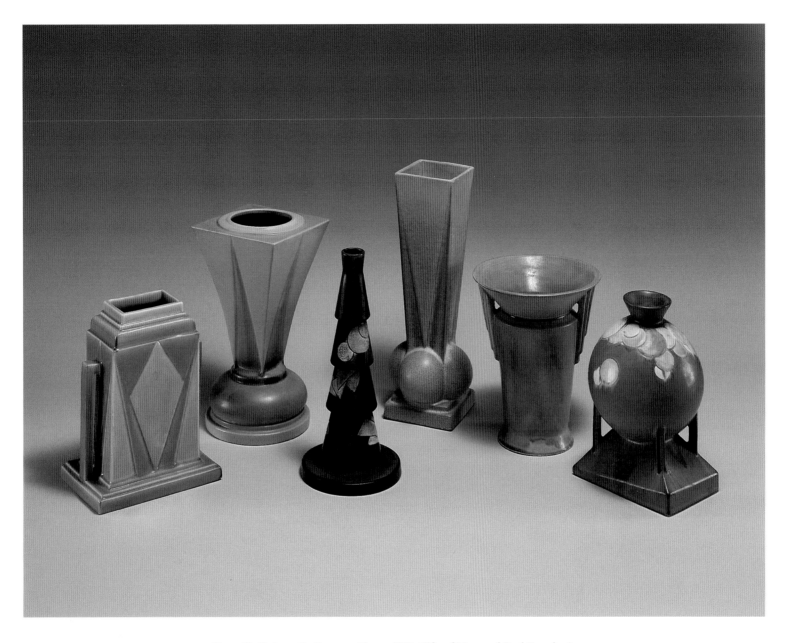

Roseville Pottery Co. FUTURA Group. 1928. Gifts of Mary and Paul Brandwein

These moderne shapes have stood the test of time well, and are avidly collected today.

forms. This decoration is accented by pierced sections, unusual in Roseville production because of the technical problems involved.

Many of the Roseville lines used a mottled glaze as a background for the molded decoration. Dahlrose, for instance, has a reddish-brown glaze mottled with ivory. Ferrella has a similar glaze, but of a different color. Some lines use a textured background, such as Luffa, Cherry Blossom, and Blackberry.

The range of Roseville designs was staggering when one looks at the entire production of the pottery. The early Rozane wares were in the typical Beaux-Arts style, in imitation of Rookwood, with flourished handles, dark tones, and glossy glazes. There were lines that referred to classic art, such as Donatello, Olympic, Normandy, and Old Ivory. Blackberry, Luffa, and Imperial I appeared rather rustic, while many Jonquil and Snowberry pieces were delicately graceful. Woodland and Rosecraft had their sources in Art Nouveau, but Futura and Moderne were definitely of the 1930s. Some, like Clematis and Bleeding Heart, had extremely

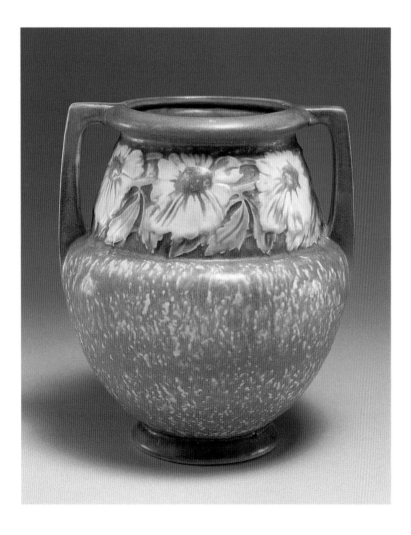

Roseville Pottery Co. DAHLROSE VASE. 1924. Earthenware, H. 8, Diam. 7½". Mark: original Roseville Pottery black paper label affixed to bottom. Gift of Mary and Paul Brandwein

OPPOSITE: **Roseville Pottery Co. FERRELLA VASE. 1931. Earthenware, H. 4⅛, W. 6". Mark: silver Roseville Pottery sticker on bottom. Gift of Mary and Paul Brandwein**

Characteristic of Ferrella is the incised seashell-like motif that forms the neck and base of the objects.

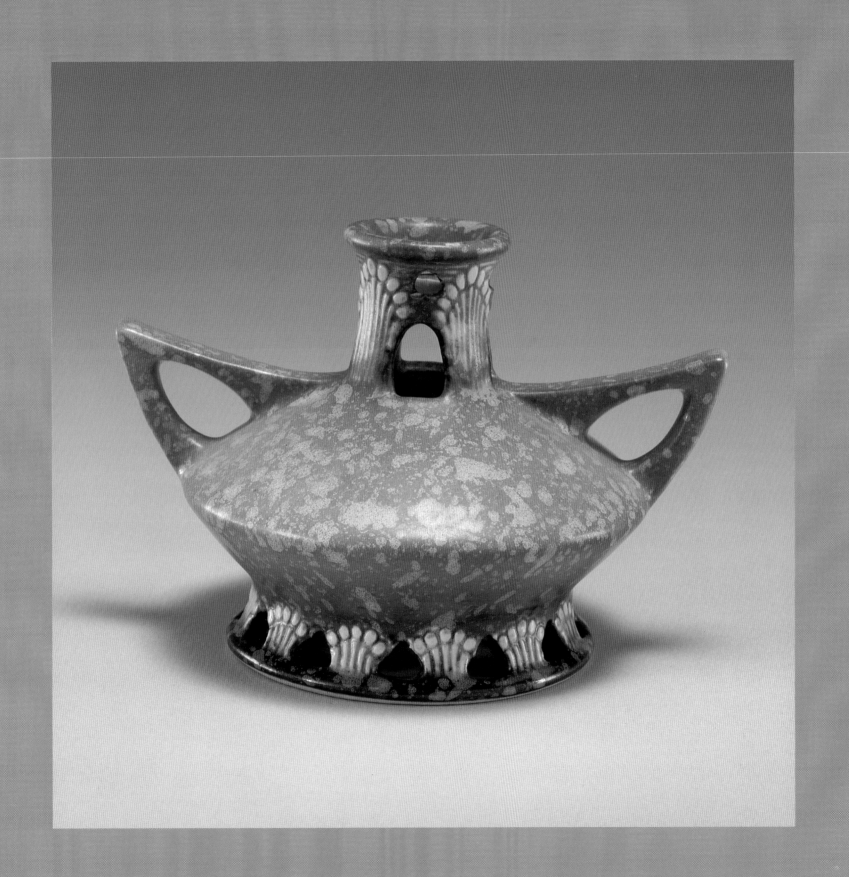

exaggerated shapes, while others, such as Orian and Russco, were more restrained. Mostique refers to Native American motifs, very popular at the time. Most lines were finely designed and infinitely appealing, but a few are a bit specious.

The change from hand decoration to mold-made wares was a drastic technical change, but the general focus of the wares remained the same. Roseville had always accented floral motifs, and the new lines continued this interest. Underglaze slip decoration had a textured surface caused by the thickness of the brushstrokes loaded with slip, and the molded wares simply continued and exaggerated this kind of surface. Roseville designers had always been more conscious of shapes than had the designers at other art potteries, and this accent on shape received even more focus in the later work. So the change to molded wares at Roseville was not as overwhelming as was the change to incised matte wares at Rookwood.

There are no company records listing the names of the designers and decorators who worked for Roseville over the years.[20] Those who are known have been remembered by people who knew or worked with them, or have been identified by their signatures on the works, or may only be known by their monograms. Generally speaking, designers are better known than decorators, although there is some disagreement over who designed what, and in what year.

The name Duvall appears on a Rozane vase decorated with roses from the Brandwein Collection at the Everson. This could have been done by either Charles Duvall or Katy Duvall, both of whom decorated Rozane wares. Since Charles seems to have specialized in portraits and animals, perhaps it was Katy who decorated this lovely piece. Josephine Imlay, who had worked for Weller before her tenure at Roseville, decorated Rozane Royal Light. Grace Neff, who specialized in floral motifs, decorated a piece of Rozane ware with pansies that is now in the Brandwein Collection.

Hester Pillsbury, who also worked at Weller, decorated Rozane for Roseville. The Timberlake sisters, Mae and Sarah, also worked for Roseville, decorating Rozane Royal Light, before moving on to Weller. R. G. Turner specialized in portraits at both Roseville and Weller.

Designers played a more important role at Roseville than at any other pottery, since so much of the production was molded. The designer produced a scale drawing of his proposed design, adding ten percent for shrinkage of the clay during drying and firing. Then he created a watercolor sketch, indicating colors to be used. Frederick Hurten Rhead, already mentioned, was one of Roseville's most talented designers. He came from a family of artists and potters in the Staffordshire district in England, and was well educated in modeling and painting. Rhead came to the United States in 1902 and worked at Vance-Avon and Weller before coming to Roseville in 1904. Rhead brought new and innovative techniques to Roseville. When he left Roseville in 1908, he was succeeded by his brother, Harry, who designed the famous Donatello line.

John Herold was an Austrian who had been educated in art schools in Europe. He was a versatile man, and he not only decorated Roseville ware, but also served as plant superintendent, developed clay bodies and glazes, and

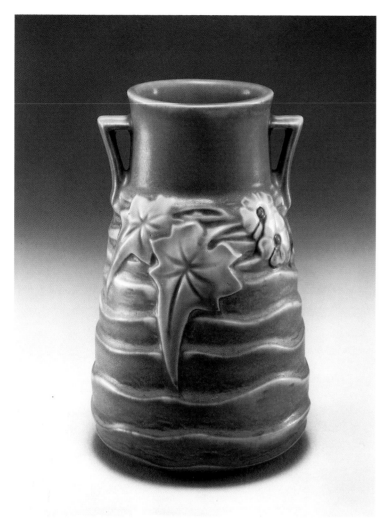

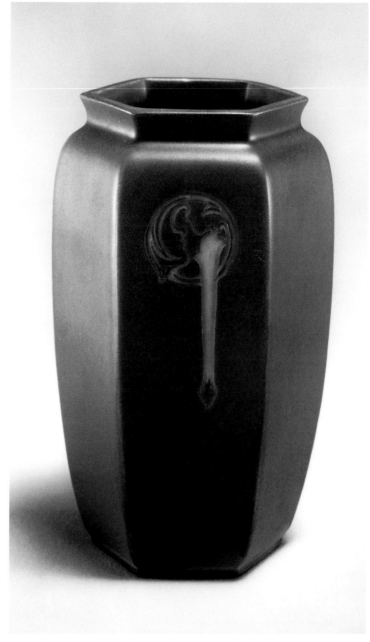

Roseville Pottery Co. Luffa Vase. 1934. Earthenware, H. 6¼, Diam. 3¼".
Mark: sticker of Roseville Pottery Exhibition, January 1980 on bottom.
Gift of Mary and Paul Brandwein

Right: Roseville Pottery Co. Rosecraft Panel Vase. 1920. Earthenware,
H. 10, Diam. 5". Mark: Roseville monogram stamped in blue on bottom.
Gift of Mary and Paul Brandwein

worked as a designer. He was responsible for the creation of Rozane Mara, Roseville's answer to Weller's Sicardo ware, and Rozane Mongol. Christian Nielson, a Dane, designed Egypto under Rhead's direction.

As at other art potteries, there were many other people who were just as responsible for the look of the products as were the designers and decorators. The glaze technicians produced hundreds of samples, from which only a very few would be chosen for production each year. The men who fired the kilns were highly skilled technicians upon whom depended the entire production, for a carelessly fired kiln could result in devastating losses for both the pottery and the decorators who had spent so much time and talent on the ruined wares. Successful art potteries were definitely group projects, and Roseville perhaps more so than others.

Other Art Potteries
Rookwood, Roseville, and Weller were the most prolific and are the best known of the art potteries, but there were many others all over the country that produced these wares as well. They were large and small, successful and not, well managed and bungled, some highly productive and some more intent on producing a few artistically fine pieces at a time. They were clustered on the Eastern seaboard, in

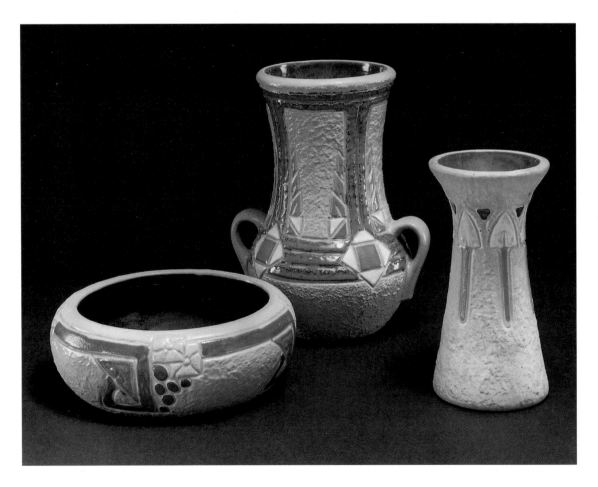

Roseville Pottery Co.
Mostique group.
LEFT TO RIGHT: MOSTIQUE BOWL.
1915. Earthenware, H. 3¼, Diam.
9". Mark: none. MOSTIQUE VASE.
1915. Earthenware, H. 10, Diam.
8½". Mark: none. MOSTIQUE VASE.
1915. Earthenware, H. 8, Diam.
4". Mark: *164* impressed on bottom. Gifts of Mary and Paul
Brandwein

Mostique was immensely popular when first produced, and has remained so today.

Roseville Pottery Co. MOSTIQUE
JARDINIERE AND PEDESTAL. 1915.
Earthenware, Pedestal H. 18½,
Diam. 12"; jardiniere H. 10,
Diam. 12¼". Mark: none. Gift of
Mary and Paul Brandwein

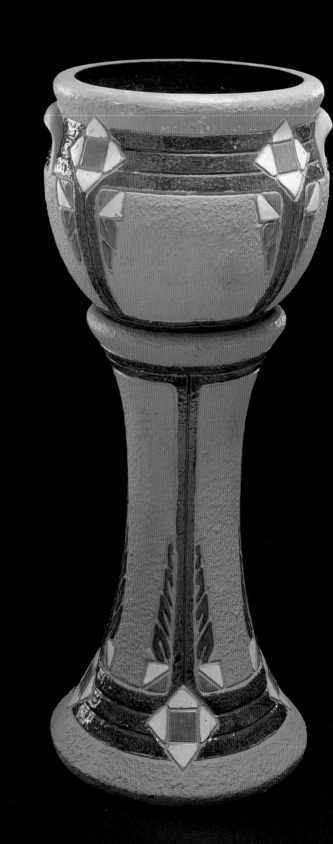

Ohio, and on the West Coast, but they also appeared in out-of-the-way places like Denver and Colorado Springs; Biloxi, Mississippi; Mason City, Iowa; Cambridge City, Indiana; Benton, Arkansas; and Erlanger, Kentucky. The larger cities such as Chicago, Detroit, New York, New Orleans, and Boston also were sites for potteries. The movement was a national phenomenon.

In Zanesville, J. B. Owens Pottery was a very successful venture and a serious competitor of Weller and Roseville. Like so many of the other art potteries, Owens grew out of a manufactory that specialized in functional wares, such as flowerpots, teapots, and kitchenware. The pottery was established in 1885, and by 1893 it had grown to the same production capacity as Weller. Owens added its art line in 1897, following Weller, but preceding Roseville. The first art wares were in imitation of Rookwood Standard, and were called Utopian. The motifs were the usual flowers, fruits, and portraits. This line was successful, and soon Lotus was introduced, which was a lighter version of Utopian, similar to Rookwood Iris.

Owens employed a number of decorators and designers who had worked at other art potteries during their careers, resulting in wares similar in style and motifs to potteries located in Zanesville and elsewhere. It is difficult to tell the origin of an unmarked piece of early art pottery decorated in the Rookwood Standard style, since the decorators and glaze technicians moved from working place to working place. This also accounts for the homogeneous look of American art pottery.

The Brandwein Collection has a pitcher in the Utopian line decorated with a sprig of cherries. The technique is painterly and the decoration glows beneath the glossy overglaze. Owens glazes were very fine, and not as dark or murky as those used by Weller or Roseville on their early slip-decorated wares. As a result, the underlying decoration is more pronounced and the colors are clearer and more sparkling.

Owens was careful to hire well-educated designers, decorators, and technicians, many of whom came from Europe. Initially, W. A. Long helped Owens establish the Utopian line, for he knew the underglaze slip-painting technique. The Timberlake sisters, Mae and Sarah, worked for Owens, as did Charles Chilcote. These decorators had also worked for Weller and Roseville. Frank Ferrell, who also worked for Weller and Roseville, designed a new art ware, called Owensart, for Owens. He was joined by Hugo Herb, a German wax modeler, and Guido Howarth of Austria-Hungary, who designed and decorated some of the lines associated with Owensart. John Herold, who had worked at Roseville with Frederick Rhead, also decorated for Owens.

Like its Zanesville competitors, Owens also added lines in imitation of Rookwood, and of the other area potteries. Owens's Henri Deux design of 1902, with incised areas filled with color, was probably inspired by Weller's Dickens' Ware line, and may have, in turn, encouraged Roseville's institution of the Della Robbia line. Henri Deux was decorated in the main with Art Nouveau motifs. In fact, of the three Zanesville potteries, Owens produced the most lines with Art Nouveau styling. Opalesque, introduced in 1905, was decorated over the glaze with metallic colors, perhaps to compete with Weller's Sicard ware. Venetian had a metallic iridescent glaze, too, in imitation of Sicard ware. A rather unique line, Feroza Faience, introduced in

J. B. Owens Pottery. UTOPIAN PITCHER WITH CHERRIES. c. 1900. Earthenware, H. 9½, W. 6¼, D. 4¼". Mark: *Utopian Owens* impressed on bottom, with *A 13*. Signature: *C or L* under glaze on side. Gift of Mary and Paul Brandwein

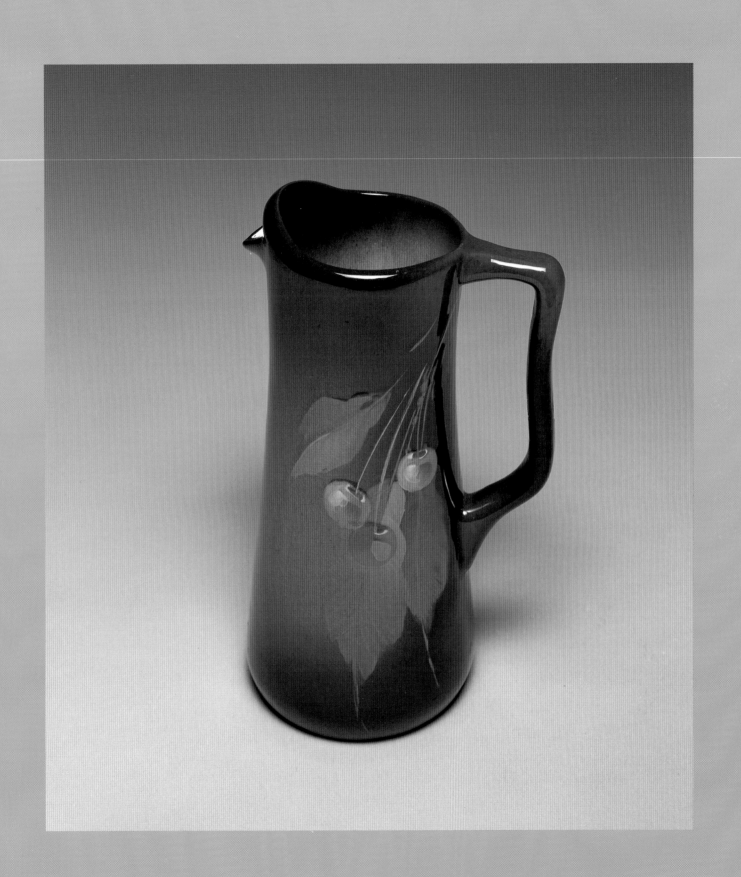

1901, had a surface resembling the hammered metal wares so popular then with the aficionados of the Arts and Crafts style, and was glazed with a bronze metallic glaze. Another design that related to the Arts and Crafts style was called, appropriately enough, Mission, and some of the pieces were accompanied by an oak receptacle that would blend in with the oak Mission furniture produced by Gustav Stickley and other craftsmen of the period.

Owens, like many other art potteries of the time, produced wares using a Native American theme. Owens, Weller, Rookwood, Clifton Art Pottery of Newark, New Jersey, Lonhuda Pottery of Steubenville, Ohio, and many others created wares either inspired or copied from Native American examples, some based on original works in the Smithsonian collections. Both shapes and surface designs were imitated. Besides trying to approximate the look of Native American wares, many potteries used American Indian figures on their portrait vases, painted in slip under the glaze.

Owens was one of the largest and most successful of the early art potteries, but its success was short-lived. In its heyday, Owens employed as many decorators as did Rookwood, and its volume of production rivaled the Cincinnati pottery as well. The quality of Owens work was very high, making it a close rival of Rookwood. With the emphasis on high-quality art work, Owens dropped its utilitarian lines, which may have contributed to the financial crisis that caused the closing of the pottery in 1907. Owens also produced architectural tiles, and this phase of the business flourished to such an extent that it was bought out by a syndicate of its competitors.

Zanesville was known as "The Clay City," for the pottery business was its main source of revenue, going as far back as 1810. The surrounding hills contained clay in abundance, and railroads made nationwide markets available. Weller was the first to make art pottery, and with Owens and Roseville comprised the three major producers in Zanesville. Other smaller potteries followed suit, however, including Peters and Reed; A. Radford and Company, which used molds from the English Wedgwood company to produce its jasper ware; and Nielson Pottery Company, founded by Christian Nielson who had worked at Roseville, produced art pottery for a brief time, for it was in business for only about one year. The Ohio Pottery in Zanesville, which made high-quality chemical and utilitarian wares, hired John Herold, who had worked at Weller and Owens. There, Herold created an art line called Petroscan, which had a true porcelain body. These smaller Zanesville potteries never attained the popularity nor the production of the three larger manufactories.

In the earliest years of the development of art pottery in Cincinnati, the T. J. Wheatley & Co. pottery played a significant role in the development of "Cincinnati faience," as the earliest wares came to be known. Thomas Wheatley had studied at Cincinnati's School of Design and had been associated with the Coultry Pottery in that city, where he taught the technique of underglaze decoration. He established his own pottery in 1880, several months before the establishment of Rookwood, where he produced underglaze slip-decorated wares. These were decorated with brushes heavily laden with slip, which left a thick impasto on the

T. J. Wheatley and Company.
VASE. 1880. Earthenware, H. 12,
W. 7¾, Diam. 3". Mark: *TJW &
Co/pat* (illegible) *48/1880* incised
on bottom. Museum purchase

*This vase illustrates the early attempts
to imitate French barbotine wares.
Wheatley was one of the first to
attempt this in Cincinnati.*

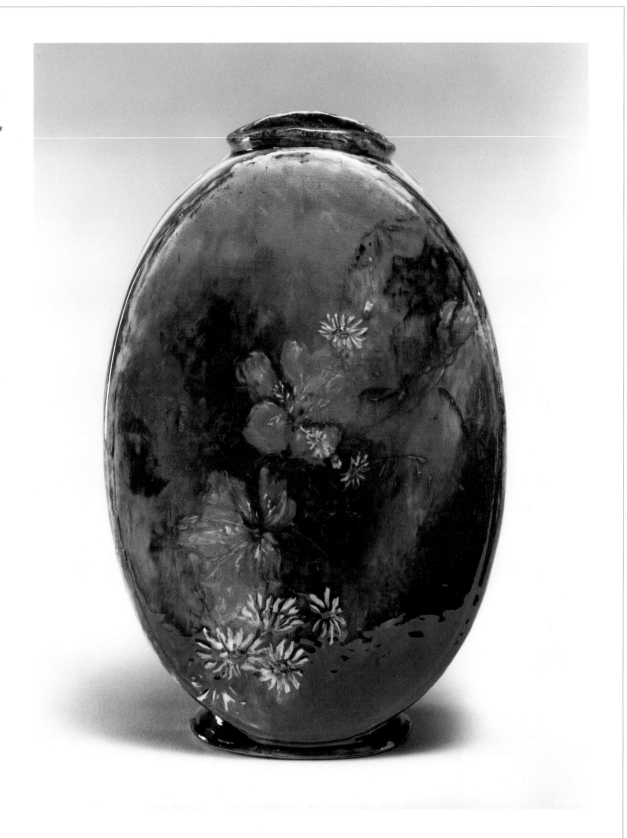

surface, giving the vessels a highly textured surface. A clear glaze was added overall. While the technique was the same as that used to produce Rookwood Standard, the results were quite different because of the colors and glazes used. The backgrounds appear rather mottled, since the colors were applied with a brush rather than with the atomizer or airbrush used at Rookwood. The impasto is thicker than that used at Rookwood, and the general appearance of the objects is not as sophisticated as that of Rookwood, even in its bizarre period. But Wheatley was of great importance to the art pottery movement, for he was one of the innovators who used the slip-decorating technique successfully.

Another early artist whose work is now highly valued is Englishman John Bennett. Produced before the typical Rookwood Standard style was developed, Bennett's work was closely related to the work of the English Arts and Crafts designers and to that of the Symbolists. The forms are simple and classic, usually without handles or any relief ornament. The decorations, made under the glaze, are usually floral.

Reminiscent of the Symbolists was Bennett's use of large areas of color and forms outlined in black. His colors are rich, bright, and luscious. He painted the floral motifs first, then brushed on the background (the use of the atomizer had not yet been discovered). As a result, his backgrounds are not smooth and shaded, but often rather painterly, with the brushstrokes in evidence. After applying the decorative motif and the background color, the design was outlined in black, or a very dark color. The final effect is stunningly colorful.

Bennett worked in New York, but had been trained in his native Staffordshire as a china painter. He taught at Doulton, and his works were included in that manufactory's display at the Philadelphia Centennial Exposition. There they were so enthusiastically accepted by the Americans that Bennett decided to move to New York in 1877. As a consequence, Bennett brought with him the influence of the English reformers, notably William Morris and William De Morgan, to the American china painting scene.

Edward Lycett, like Bennett an Englishman by birth, is considered the father of china painting in America. He joined Faience Manufacturing Company (established in 1880) in 1884 and there he not only decorated wares, but also created clay bodies and glazes, including a metallic luster glaze. He decorated the wares himself, and also oversaw a team of about twenty-five other decorators. His tastes ran to a rather flamboyant version of the Beaux-Arts style, but his skills were extremely fine and he could restrain his exoticism when called upon to do so.

The success of Rookwood Standard wares during the 1880s may have spawned a school of imitators, but there were a large number of potteries who managed to maintain an originality of their own in spite of the clamor for slip-decorated wares. One such manufactory was American Terra Cotta and Ceramic Company, producer of Teco, the art line that has overshadowed the name of the parent organization. Teco wares have a distinct personality and rely on form almost entirely, devoid of applied surface decoration. Teco appeared in 1901, produced by a firm that made sewer pipe and bricks. The forms often derive from nature, with strap-like leaves providing a departure point for the creation of graceful, clearly defined sculptural pieces. Many of

American Terra Cotta and Ceramic Co. (The Gates Potteries). TECO VASE. n.d. Earthenware, H. 13¾, W. 6, D. 6". Mark: *Teco* incised on bottom. Museum purchase

Form is what distinguishes the wares produced by Teco. In many instances, the designs were developed or inspired by architects, accounting for the attention to sculptural forms and lack of surface decoration.

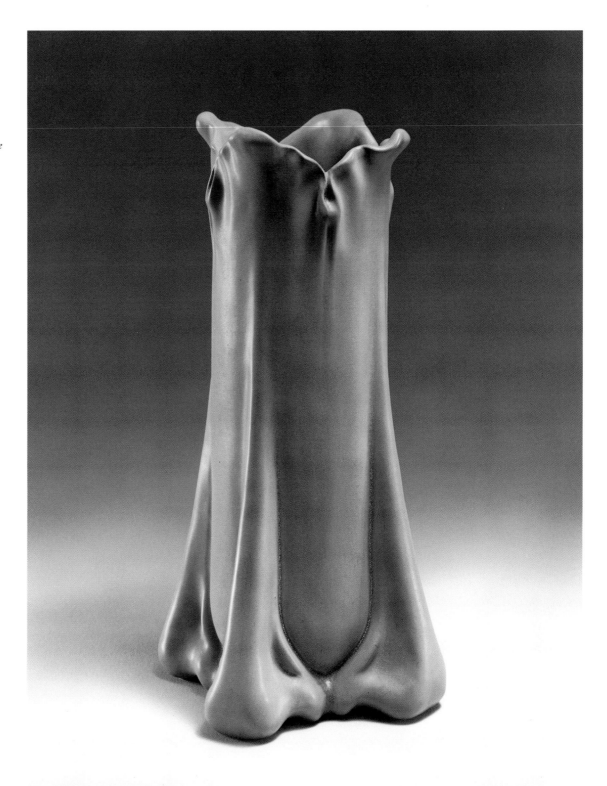

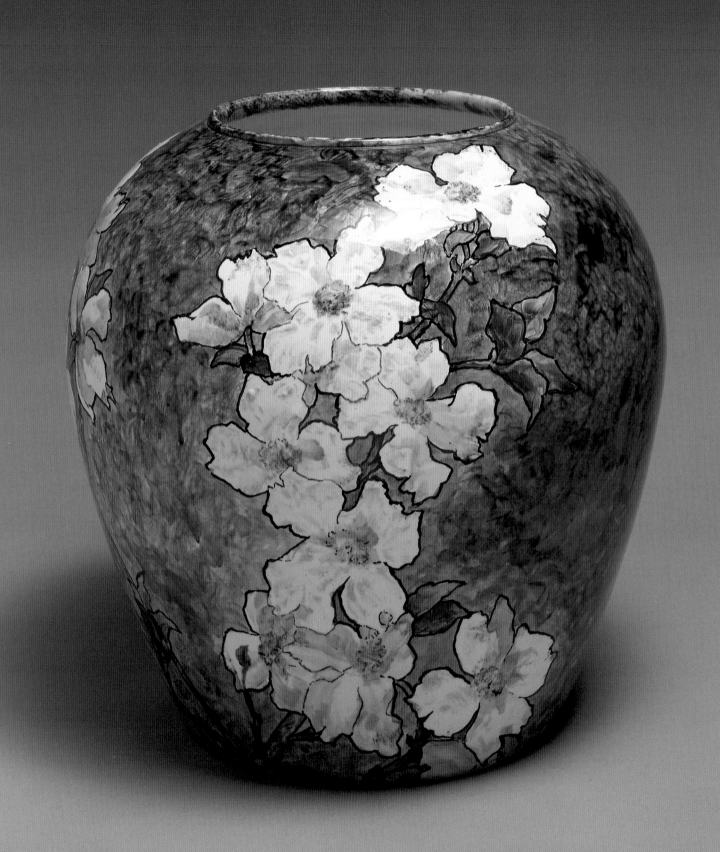

Faience Manufacturing Company. Attributed to Edward Lycett. VASE. 1884–92. Porcelain, H. 10¼, Diam. 5¼". Mark: entwined monogram of company stamped on bottom. Museum purchase with funds from the Dorothy and Robert Riester Ceramic Fund

The raised gold filigree–like lines on this vase add a sense of richness and relate it to other late Victorian works and also to Japanese Satsuma wares.

OPPOSITE: **John Bennett Pottery. DOGWOOD VASE. 1878–83.** Earthenware, H. 12, Diam. 12". Mark: *J Bennett* on bottom. Museum purchase

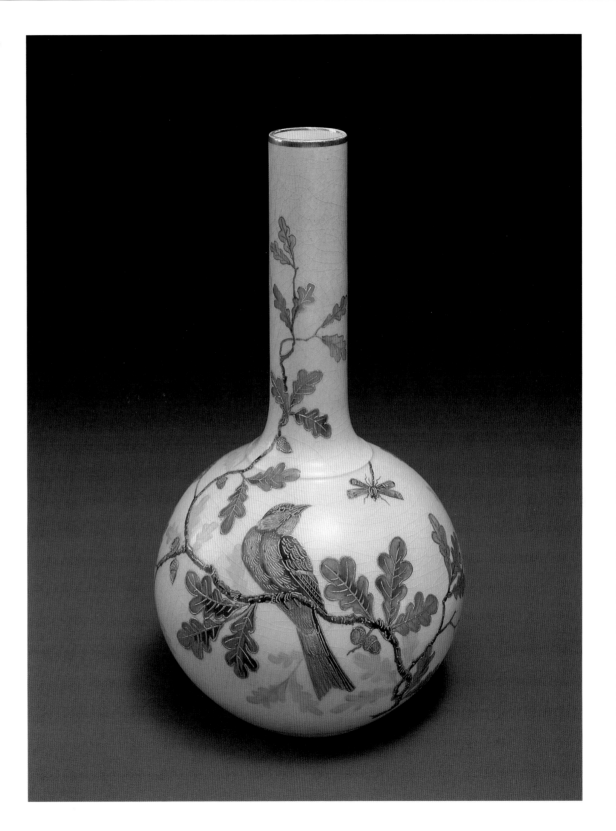

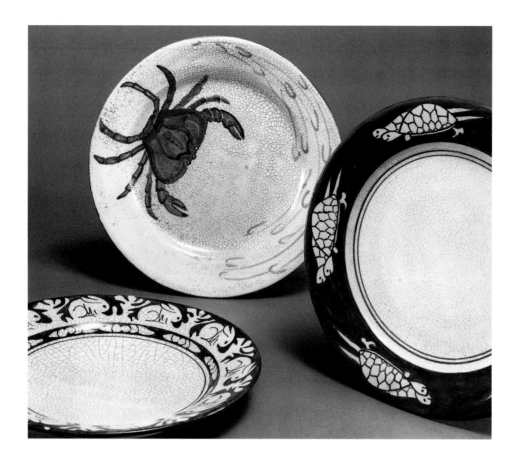

LEFT TO RIGHT: Dedham Pottery. Group of plates:
RABBIT PLATE. 1896–1929. Earthenware, H. 1,
Diam. 8⅛". Mark: Dedham pottery stamp in blue
on back. Gift of Mary and Paul Brandwein.
CRAB PLATE. 1896–1928. Earthenware, H. 1½,
Diam. 8¾". Mark: Dedham rabbit imprinted in
blue on back. Gift of Albert E. Simonson in
memory of Priscilla Lord Simonson. TORTOISE
PLATE. 1896–1928. Earthenware, H. 1, Diam. 8½".
Mark: Dedham rabbit imprinted in blue, and
a foreshortened rabbit impressed on back.
Gift of Albert E. Simonson in memory of
Priscilla Lord Simonson

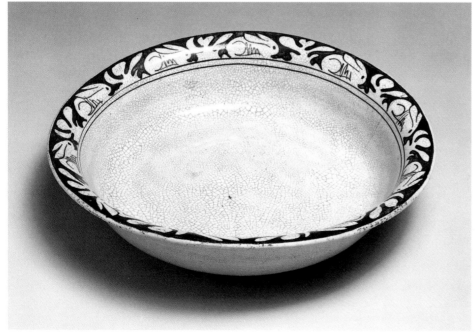

Dedham Pottery. Joseph Smith, designer. RABBIT
BOWL. 1896–1928. Earthenware, H. 3, Diam. 12½".
Mark: Dedham rabbit imprinted in blue, and
foreshortened rabbit impressed on back. Gift of
Mr. and Mrs. John S. Hancock

the early forms were designed by the owner of the firm, William Day Gates, a lawyer by training and potter by inclination. A number of his friends who were architects also provided designs, accounting for the architectural look that became Teco's trademark. The pottery is often glazed in a distinctive silvery gray-green matte glaze, adding to its distinctive look.

The Robertson family played important roles in several art pottery ventures. Initially, James Robertson and his sons George W., Hugh C., and Alexander W. had operated Chelsea Keramic Art Works, a family pottery in Chelsea, Massachusetts. They had begun to make art pottery there in 1872,[21] but that venture was not successful. Hugh and George established the Chelsea Keramic Art Tile Works at Morrisville, Pennsylvania in 1890, but the endeavor had financial difficulties and resulted in George becoming superintendent, with his backer, Arthur Frost, as president. Meanwhile, Hugh returned to Chelsea to form The Chelsea Pottery, U.S., in 1891, with the backing of Arthur A. Carey. Robertson oversaw the operation of the pottery, and realizing the need for a commercially appealing product, he resumed research on a crackle glaze that he had been working on at the old Chelsea Keramic Art Works. The glaze was soon realized and the resulting wares were wildly successful for many years.

The gray crackle surface was decorated with borders in cobalt blue with various motifs, but by far the most popular was the rabbit designed by Joseph L. Smith. On the first batches produced, the rabbits went counterclockwise, but it was soon discovered that they proved difficult to decorate "in reverse" and the rabbits were turned around to face in the opposite direction. New designs were added, some contributed by art students who vied for prizes.

Initially, the molds included the raised decoration which would then be hand-decorated in the ubiquitous Dedham blue. However, this resulted in rather stilted decoration, and prior to 1895 the method was abandoned and the molds smoothed for further use. However, not all molds were entirely smooth, and as a result, it is possible to find pieces with the remains of one raised pattern overpainted in blue with another pattern. The crackled surface of Dedham ware was obtained by quickly cooling the ware as it emerged from the kiln. The resulting crackle was rubbed by hand with Cabot's lamp black powder to accent the crackled surface.[22] In 1895 Chelsea Pottery moved to Dedham, Massachusetts, where its name was changed to Dedham Pottery. It continued to produce the crackle wares until the pottery closed in 1943.

While working at the original Chelsea Keramic Art Works, Hugh Robertson began an intense investigation of glazes, with an underlying purpose of recreation of the ancient Chinese *sang de boeuf* glaze. His experiments so engrossed him that he neglected the operation of the pottery, which had to close because of financial distress. But in spite of this, Robertson produced some of the richest and most unique glazes of the period.

Glazes consumed the attention of William H. Fulper, Jr., too. The Fulper Pottery had been in operation since 1814[23], and began to make art wares in 1909. The art line was called Vasekraft, and a wide variety of shapes were produced: vases, bookends, candleholders, pitchers, tiles, and others. The most distinctive aspects

Dedham Pottery. Hugh Robertson. FLAMBÉ VASE. c. 1900. Earthenware, H. 9¼, Diam. 4½". Mark: *Dedham Pottery* incised on bottom, *12R 1C* in blue pigment on bottom, *Robertson* in pencil on bottom. Museum purchase with funds from the Dorothy and Robert Riester Ceramic Fund

The overall variegated effect is created with the moltenlike streaking of red, orange, green, and pale blue.

LEFT TO RIGHT: **Fulper Pottery. Group of vases:** VASE. n.d. Stoneware, H. 8¾, Diam. 5". Mark: *Fulper* within vertical rectangle on bottom. Gift of Mary and Paul Brandwein. THREE-HANDLED VASE. c. 1920. Stoneware, H. 6½, Diam. 8¾". Mark: incised vertical Fulper mark on bottom. Museum purchase with funds from the Dorothy and Robert Riester Ceramic Fund. HANDLED VASE. c. 1923. Stoneware, H. 9½, Diam. 7". Mark: raised vertical Fulper mark on bottom. Gift of the Social Art Club. THREE-HANDLED BOWL. c. 1923. Stoneware, H. 4¼, W. 5". Mark: *Fulper* in vertical rectangle on bottom. Gift of Mary and Paul Brandwein. BLUE VASE. Stoneware, H. 8, W. 10". Mark: *FULPER* on bottom. Gift of Mary and Paul Brandwein

of Fulper wares are the hundreds of rich and varied glazes that grace the forms. There are lusters, mattes, high-gloss glazes, and crystallines. The most prestigious was the "famille rose," which repeats the ancient Chinese color so prized by collectors.

J. Martin Stangl became superintendent of the technical division of the pottery about 1911, and he continued to develop new and distinctive glazes. After the death of William Fulper in 1928, Stangl gained control of the firm and continued its operation until his death in 1972. In 1955 the corporation's name was changed to the Stangl Pottery Company.

Although Dedham and Fulper glazes are unique and inventive, when one thinks of glazes in the terms of art pottery, the name Grueby immediately comes to mind. "Grueby green" was the buzzword of the time. Grueby Pottery of Boston, originally established to produced glazed bricks, tiles, and architectural terra cotta, began to produce art wares about 1897.[24] It was during these first years that Grueby created his ubiquitous green glaze, which became the rage of the American ceramic world. Just as they copied Rookwood Standard, every pottery copied this dark matte green, but none could compare with the Grueby version, a deeply colored, slightly lustrous matte which has been compared to watermelon rind.

Like the other potteries of the time, Grueby Pottery depended on nature for its decorating motifs. But where other establishments presented realistically painted blossoms under the glaze, Grueby used only the leaves (though very subdued blossoms do occasionally appear) and modeled them to enfold the form in shallow layers. The deep matte green, typical of the time, and the subdued natural forms mingled comfortably with the Arts and Crafts furniture and interiors of the time. The wares were heavily potted, which made them look at home with the heavy, simple forms of Mission furniture. Restrained, controlled, reserved, but often with an undercurrent of energy, Grueby Pottery epitomized the taste of the design reformers.

Like so much of the art pottery of the period, Grueby is thought of as handmade, while in reality there was very little creative effort in its production once it had passed through the hands of the designer. Like the other manufactories, the Grueby works was a team effort. The clay was heavy, and resulted in thick-walled vessels. The forms were thrown, then passed to the decorator, who had to work quickly since the applied decoration and the wet form had to be equally damp or the decoration would not adhere during the firing. The relief decoration was applied by young women from local art schools who rolled long fillets of clay and applied them according to prescribed formulas. There was little room for creativity. The fillets were smoothed on the inner side and modeled to stand away from the body of the vessel on the outer side, giving the impression of a relief created by layers of clay applications. Both William Grueby and George Kendrick created the designs. After 1902, when Kendrick left the firm, Addison LeBoutillier designed for the pottery, but the pieces retained their original character.

It is not only the color of the glaze that is so important to the Grueby look but also the way the glaze lies upon the surface of the forms. It runs off the decoration in such a way that it accents the highest points,

Grueby Pottery. VASE. c. 1900.
Earthenware, H. 7, W. 5".
Mark: *Grueby Pottery Boston USA,*
in circle, stamped on bottom.
73 stamped, *RE* incised on
bottom. Gift of Mary and Paul
Brandwein

adding a further sense of height to the relief and leaving a light linear accent to the heavy green forms. Grueby green became an international hit, and the pottery was hard-pressed to keep up with orders. Soon, imitations were springing up, and Grueby's own invention became his Nemesis. The market became saturated, right around the time that tastes were moving away from the heavy Arts and Crafts style. Grueby, whose reputation was built on the heavy, somber matte wares, had no other offering for its fickle public. The pottery ceased production of art pottery between 1910 and 1912.[25] It did, however, continue to produce tiles, the original product of the pottery.

The accent on form so evident in Grueby wares is also found in the elegant works produced by the Tiffany studio in Corona, New York. Tiffany designated his wares Tiffany Furnaces' Favrile pottery, favrile meaning handmade. But again, the designation is quite misleading, for the wares were not handmade, but rather were cast in molds. In fact, sometimes the pottery went so far as to use actual flowers and plants to create the molds. This was accomplished by spraying the flowers and foliage with shellac until they were rigid, then making a mold of them.[26] There was no painted decoration on such pieces. The motifs were totally integrated with the form, and the lush glazes accent this integration, and neither intrude nor speak out on their own.

The subtly rich *Vase with Pansies* is a fine example of this integration and use of glaze. The stems spring vigorously from the base and emphasize the more intricate floral motif above. The excised areas accent the form and provide edges to catch areas of glaze. They also emphasize the fact that this vessel was made to give aesthetic pleasure, rather than function as a container. The glaze, a subtle gray-green with some iridescence, relates the piece to nature, and suggests a dewy atmospheric environment for the blossoms it bears.

While Grueby and Tiffany were altruistically pursuing grace and beauty, the Newcomb Pottery in New Orleans was functioning on a more realistic level. Newcomb College was the women's division of Tulane University, and its pottery was established precisely to provide training for women so that they could earn a respectable living. There was the usual division of labor, with men throwing the forms, developing the glazes, and doing the firing, and the women doing the decorating. George Ohr, the naughty boy of American art pottery, worked at Newcomb for a time, but his behavior around the young women led to his replacement.

From the beginning, Mary Sheerer was hired to supervise the women. Sheerer had studied at the Cincinnati Art Academy and moved in the circles of the women who were involved in the development of Rookwood. She became knowledgeable in the mixing of clay bodies and the concoction of glazes, but at Newcomb she was seldom given proper credit for her contributions to the development of the pottery.[27] The earliest wares were decorated with the underglaze slip technique, which was soon replaced by underglaze painting. This, in turn, was replaced by an incising technique on wet clay, and painting the design after the bisque firing. Initially, the ware was covered by a gloss glaze, but as matte glazes became more popular, this quickly replaced the glossy surface. Decorative motifs were taken from nature, with the bayous of Louisiana a favorite subject.

Newcomb Pottery. Henrietta Bailey, decorator; Joseph Meyer, potter. VASE. c. 1905. Earthenware, H. 6, Diam. 2¾". Mark: NC monogram and *HB* incised on bottom. *HD59* painted, *262* stamped, *C/40* incised, and *JM* incised on bottom. Museum purchase

RIGHT: Newcomb Pottery. Esther Huger Elliot, decorator. LILY VASE. 1902. Earthenware, H. 16⅜, Diam. 8½". Mark: *124/E.H.E./N* within a *C* painted on bottom. Museum purchase

Tiffany Pottery. Vase with Cover. c. 1901. Stoneware, H. 8¾, Diam. 3⅞".
Mark: LCT monogram, *LC Tiffany Furnaces,* and *P5111* incised on bottom.
Gift of Mr. and Mrs. Bronson A. Quackenbush

Opposite: Grueby Pottery. Vase. c. 1900. Earthenware, H. 12½, Diam. 8½".
Mark: *Grueby Pottery Co. Boston. U.S.A.* encircling lotus flower impressed
on bottom, *8* impressed on bottom. Museum purchase with funds
from the Dorothy and Robert Riester Ceramic Fund

Tiffany Pottery. Vase with Pansies. c. 1910. Stoneware, H. 10⅛,
Diam. 4½". Mark: LCT monogram incised on bottom.
Gift of Mr. and Mrs. Bronson A. Quackenbush

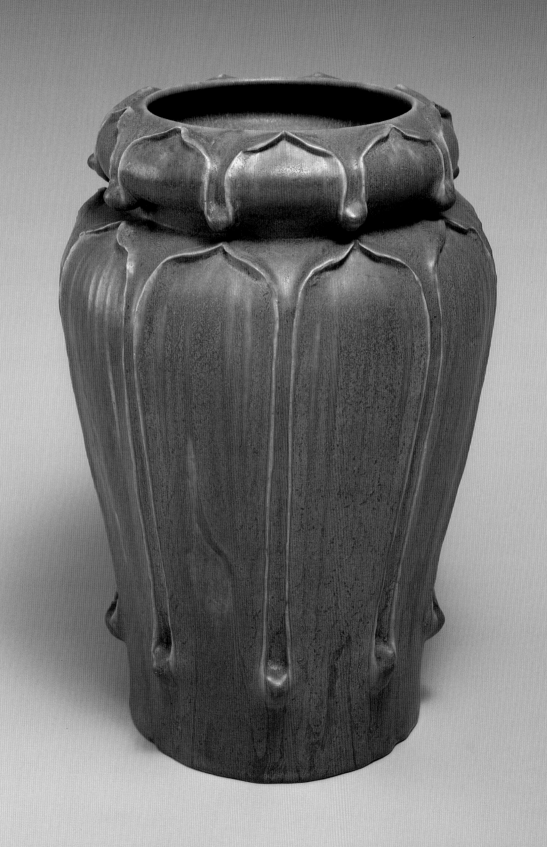

George Ohr, undaunted by his dismissal from Newcomb, returned to Biloxi, Mississippi, where he had established a pottery a few years earlier. Ohr is undoubtedly one of the most unique and gifted of all American ceramists, and his works are just as idiosyncratic as he was. Although he operated a pottery as a commercial venture (he had a large family to support), he was, in reality, a studio potter. He worked alone (his son Leo helped him prepare the clay) and produced an incredibly large number of works, none exactly like the other. Ohr was a genius at the wheel, able to throw amazingly thin-walled vessels which he "tortured" into unusual and sometimes bizarre shapes. He pinched, twisted, folded, crushed, and otherwise distorted his thrown forms, creating vessels that eloquently sing of the character of the clay from which they are formed. His *Folded Vase* is a particularly telling example of Ohr's sensitivity to his material and the unique way in which he is able to convey its characteristics to the viewer. One wishes to touch, and to turn his twisted vessel, which seems still malleable in spite of its exposure to the kiln.

Ohr was just as adept at creating unusual glazes as he was at creating idiosyncratic shapes. In fact, his contemporaries, unable to comprehend the eccentricities of his vessels, did recognize the richness and variety of his glazes. Barber[28] noted that "The principal beauty of the ware consists in the richness of the glazes, which are wonderfully varied, the reds, green, and metallic luster effects being particularly good."

Glazes were of particular interest to Artus Van Briggle, a young artist who worked at Rookwood from 1887 until he moved to Colorado 1899. He was a favorite of Maria Longworth Nichols, and she arranged for him to have a private decorating room at the pottery. He became one of Rookwood's finest artists, both as a decorator, and a potter. Van Briggle was sent by the pottery to Paris to study for two years, and while there pursued the creation of a rich matte glaze. Upon his return to Cincinnati and Rookwood, he continued his work and his glaze experiments. His health was not good, however, and he moved to Colorado to take advantage of the drier and cleaner air.

There he established his own pottery, where he produced his elusive matte glaze. He was supported in this by both the encouragement and the financial assistance of Maria Longworth Nichols, now Mrs. Belamy Storer. She had remained his friend and patron even after he left Rookwood. Van Briggle was also steadily encouraged by his wife, Anne Gregory, whom he had met during their student days in Paris.

Van Briggle's work eschews the surface decoration that he used at Rookwood in favor of sculptural motifs that seem to emerge or grow from the form itself. His *Lorelei Vase* is a fine example of this, as the figure seems to flow out of the vessel itself and forms the lip, as the delicate face peers into the darkness within. Van Briggle was much influenced by Art Nouveau while in France, and this style remained with him after he returned home. Many of his designs reflect the sinuous lines of the French style, with curving tendrils and other curving plant forms, and the objects are always covered with a matte glaze. After Van Briggle's death in 1904, the pottery continued to operate under the supervision of Anne. Even under Artus's direction, the pottery had produced molded wares and this method of production was continued. In later years, however, some

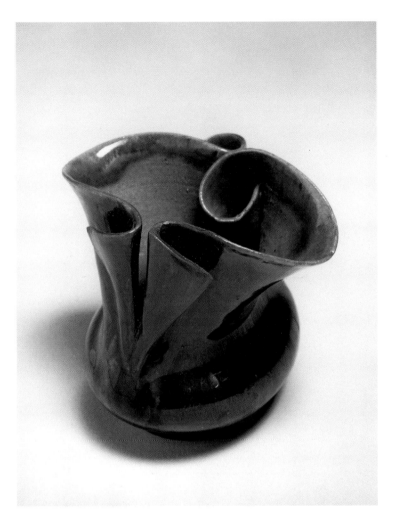

Biloxi Art Pottery. George E. Ohr, potter. FOLDED VASE. n.d. Earthenware,
H. 3½, W. 3½, D. 3½". Mark: *BILOXI MISS/GEO.E.OHR* impressed
on bottom. Gift of Mary and Paul Brandwein

*Extremely thin walls and a high degree of malleability characterize the work
of Ohr, an acknowledged virtuoso in clay.*

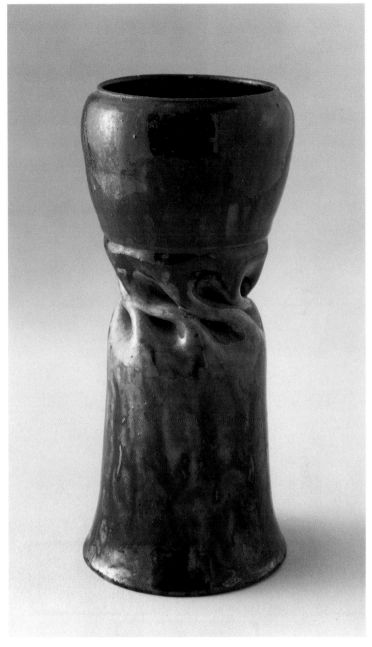

Biloxi Art Pottery. George E. Ohr, potter. TWISTED VASE. n.d.
Earthenware, H. 6¼, Diam. 3¼". Mark: *G.E.OHR/Biloxi, Miss.*
stamped on bottom. Museum purchase

*By twisting the clay, Ohr has given the piece vitality and immediacy. It is this
action of the potter's hand that makes the piece seem fresh and newly formed.*

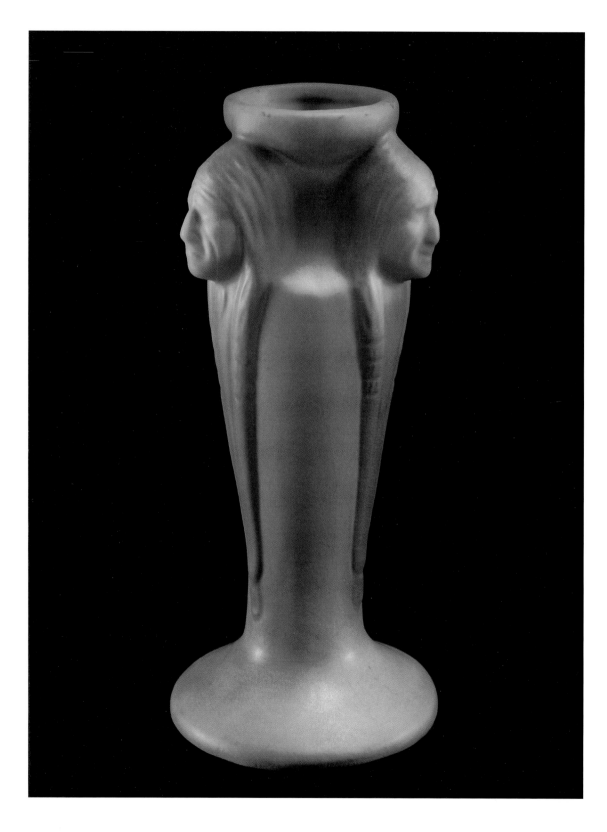

Van Briggle Pottery. INDIAN HEAD VASE. c. 1930. Earthenware, H. 11¼, Diam. 6". Mark: Van Briggle monogram and *Van Briggle Colo. Sp'gs* incised on bottom. Gift of Ronald A. Kuchta

OPPOSITE: Van Briggle Pottery. Artus Van Briggle, designer. LORELEI VASE, designed 1901. Earthenware, H. 10½, Diam. 4¼". Mark: Van Briggle monogram and *Van Briggle Colorado Springs* incised on bottom. Gift of Ronald and Andrew Kuchta in memory of Clara May Kuchta

The Lorelei, noted for its graceful form and stunning white glaze, is one of the signature works of American art pottery.

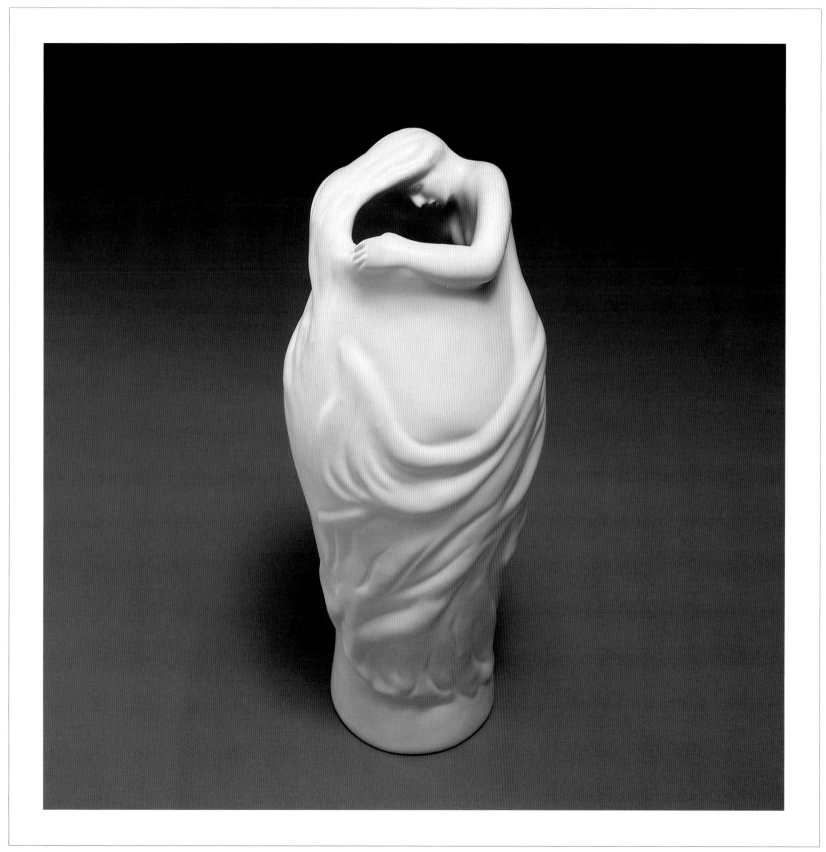

pieces of lesser quality were produced from worn molds. The company also produced tiles, commercial objects, flowerpots, and garden ornaments. There were many reorganizations of the manufactory over the years, and it is still in operation today.

Across the country, near the Old North Church in Boston, another pottery was taking form from an unusual beginning. The Saturday Evening Girls Club was an association of young immigrant women who met on Saturday evenings for readings and craft work. Soon ceramics was included, and out of this developed a pottery whose main purpose was to provide employment for these girls. The pottery was named Paul Revere Pottery because of the area of the city in which it was located. The pottery grew rapidly, though it always needed to be subsidized by its patron, Mrs. James J. Storrow. Miss Edith Brown, who also designed some of the wares, was director. Production ranged from plain and decorated vases to lamps, inkwells, and tiles. The most popular, however, were the children's wares, bowls, pitchers, plates, and so forth decorated with juvenile motifs such as chicks, rabbits, and ducks. These charming items are well designed, and the glazes are richly colored and substantial. Occasionally, decorators marked their work, but no records remain of the decorators.

Saturday Evening Girls. BOWL WITH RABBITS. 1914. Earthenware, H. 2¾, Diam. 8½". Mark: *1-14/S.E.G.* and *FL* monogram on bottom. Gift of Mary and Paul Brandwein

The glaze on this bowl is extraordinarily rich and viscous, with a deep golden yellow color.

OPPOSITE, LEFT TO RIGHT: **Van Briggle Pottery. Group of vases: FLOWER BOWL. 1913. Earthenware, H. 4½, Diam. 7". Mark: Van Briggle monogram over *1913* incised on bottom. Gift of Leonard Fried. BOWL. n.d. Earthenware, H. 2¾, Diam. 3½". Mark: Van Briggle monogram and *Van Briggle/COLO SPGS/80* incised on bottom. Gift of Nancy Farr Fulmer. VASE. Earthenware, H. 6½, Diam. 4". Mark: *VAN BRIGGLE* and cipher, *Colo, Sps* on bottom. Gift of Mary and Paul Brandwein. VASE. After 1920. Earthenware, H. 8, Diam. 3½". Mark: Van Briggle monogram and *Van Briggle Colo. Spgs.* incised on bottom. Gift of Mr. and Mrs. Victor Cole. Bowl. Earthenware, H.3¼, W. 6". Mark: Van Briggle cipher, *42/Van Briggle/Colo Spg's* incised on bottom. Gift of Mary and Paul Brandwein**

Buffalo Pottery. J. Nekola, decorator. DELDARE PITCHER, FALLOWFIELD HUNT SCENE. 1909. Earthenware, H. 6¾, W. 6⅝". Mark: Buffalo Pottery cipher with *1909* on bottom. *J. NEKOLA* under handle. Gift of Mary and Paul Brandwein

Like many of the other art potteries that also produced functional wares, Buffalo Pottery, a large commercial pottery established to produce premiums for the Larkin Soap Company in Buffalo, also produced hand-decorated wares. Because Buffalo Pottery began this hand production later in the period than most other potteries, it did not fall under the spell of Rookwood and the other art potteries producing variations of Rookwood Standard. Buffalo's most popular hand-decorated line was Deldare. The name refers to the distinctive olive-green color of the body of this ware, which was decorated with a variety of motifs.[29] The decorative schemes were provided for the decorators by Ralph Stuart, head of the art department and supervisor of the decorators, who had come to Buffalo from Onondaga Pottery in Syracuse, New York (now Syracuse China Corp.). Stuart, and several generations of his family before him, had worked in the potteries in Staffordshire. Stuart himself was said to have worked at Wedgwood and Royal Doulton. He also was related to the American painter Gilbert Stuart.[30]

The decorative motifs on Deldare ware were taken from English sources, either literature or engravings. Many of the phrases that appear on the pieces can be found in Dickens's *The Vicar of Wakefield*. The most popular are the Fallowfield Hunt series and the scenes of English village life in "Ye Olden Days." As one would expect, the style was also derived from English designs. The motifs were done in areas of flat color outlined in black, in the manner of the Symbolists, and also of Margaret Thompson and William J. Neatby, both of whom designed for Doulton & Co.

Deldare decorators followed a strict regimen in applying their colors. The scenes were drawn by Stuart and transferred to the surface of the vessel. The decorators then painted in the colors. The only area where personal creativity could come into play was in the clouds, which could be added freely by the decorator. Each decorator was responsible for mixing his or her own colors, and usually worked on several pieces at a time, applying the darkest colors first and then proceeding to the lighter. Each piece is signed with the name or initials of the decorator.

Much of the charm of Deldare ware lies in the softly subtle color scheme of rusty red, teal blue, yellow, green, brown, black, and white against the olive-green background. The entire piece is covered with a clear gloss glaze. The shapes are relatively simple and are classically English. Nearly all are marked and dated. Originally, the pieces were priced rather high (they were used for premiums for only a short time), with a small teapot selling for ten dollars, a relatively high sum in those days (a hardworking journeyman decorator at Buffalo Pottery made twelve dollars a week, paid on piecework basis). But they were popular adjuncts to the Arts and Crafts interiors of the time.

Hundreds of other art potteries operated across the country, some large, many small, some successful, others struggling. Their production varied in quality and quantity. Some, such as Hampshire, Niloak, and Marblehead are well known, while others, such as Clewell, Norse, and Shawsheen produced specialized wares or were in business for only a short time, and their wares are rarer than those of their more productive counterparts.

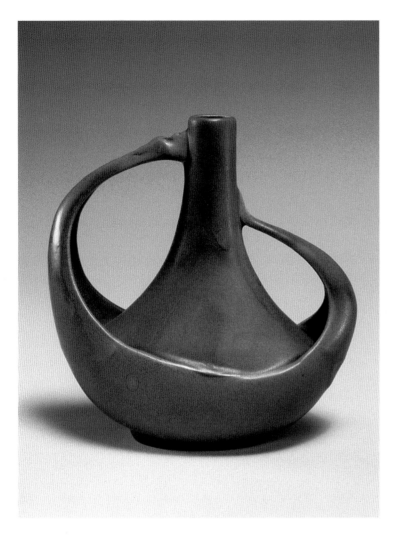

Hampshire Pottery. VASE. n.d. Earthenware, H. 5⅞, W. 5¼".
Mark: *HAMPSHIRE* impressed on bottom, barely legible.
Gift of Mr. Richard Barons

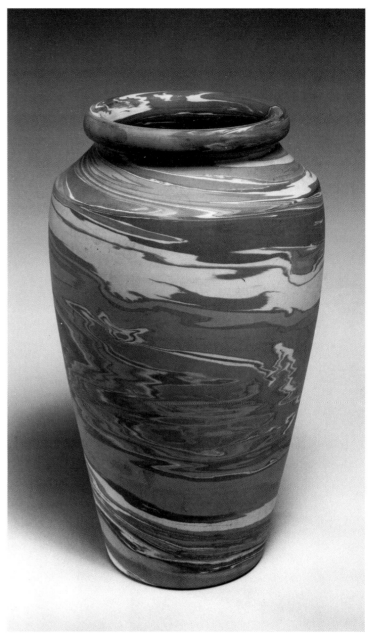

Niloak Pottery. MISSIONWARE VASE. n.d. Earthenware, H. 12, Diam. 7".
Mark: Niloak sticker from Biggs Art Shop, Hot Springs, Arkansas,
on bottom. Gift of the Social Art Club

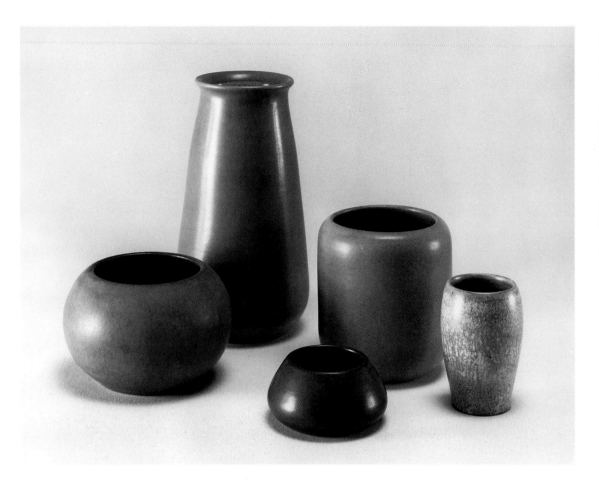

LEFT TO RIGHT: **Marblehead Pottery. Group of vases: VASE. n.d. Earthenware, H. 3¼, Diam. 5¼". Mark: Marblehead stamp on bottom. VASE. n.d. Earthenware, H. 7⅞, Diam. 4⅜". Mark: Marblehead stamp on bottom, and torn oval Marblehead sticker on bottom. FLOWER HOLDER. n.d. Earthenware, H. 1¼, Diam. 3½". Mark: Marblehead stamp on bottom. VASE. n.d. Earthenware, H. 4½, Diam. 4⅛". Mark: Marblehead stamp on bottom, barely legible. VASE. n.d. Earthenware, H. 3⅜, Diam. 2¼". Museum purchases**

Rookwood Pottery. OLMSTED VASE. 1940. Earthenware, H. 5½, Diam. 5½". Mark: Rookwood cipher/XL/S impressed on bottom; *Anna W. Olmsted* incised across body. Gift of Robert and Mary Ellen Serry

This vase, with Anna W. Olmsted incised on the body, was obviously done as a tribute to Olmsted when she visited Rookwood. Olmsted was noted and respected in the ceramics world.

A most important figure in the history of American ceramics appeared on the art pottery scene as the era drew to a close. R. Guy Cowan came from a family of potters who had worked in Ohio potteries for several generations. He was a student of Charles Fergus Binns at Alfred University, and a few years after his graduation he founded an art pottery, The Cleveland Pottery and Tile Company, based in Cleveland. The company produced both tile and artware, but closed in 1917 when Cowan joined the army.[31] Upon his return in 1919, he moved the pottery to larger quarters in Rocky River, Ohio, a suburb of Cleveland. Here he changed his clay body from a redware to high-fired porcelain and shifted his emphasis from vessels to clay sculpture. Cowan sought to produce wares that were reasonably priced and felt that the duplication of well-designed wares does not "necessarily injure the product from an art standpoint."[32]

Porcelain figures were made in limited editions, after which the mold was destroyed. Cowan hired some of the finest sculptors to create his figures, including Waylande Gregory, Paul Bogatay, Walter Sinz, and Alexander Blazys. He also hired a number of gifted students from the Cleveland School of Art (now the Cleveland Institute of Art), including Viktor Schreckengost, Thelma Frazier Winter, and Russell Barnett Aitken. Gre-

LEFT TO RIGHT: **Red Wing Art Pottery. VASE. n.d. Earthenware, H. 7½, Diam. 6". Mark:** *Red Wing Art Pottery* **stamped in black on bottom. Gift of Mary and Paul Brandwein. Clewell Metal Art. VASE. n.d. Stoneware body with metal surface, H. 13½, Diam. 5". Mark:** *Clewell 254* **incised on base. Gift of the Social Art Club. Red Wing Art Pottery. TALL VASE. c. 1930. Stoneware, H. 9¼, Diam. 4¼". Mark:** *RED WING/ART/ POTTERY* **stamped in blue on bottom,** *186* **impressed on bottom. Gift of Mary and Paul Brandwein. Hampshire Pottery. VASE. n.d. Earthenware, H. 7¼, Diam. 5". Mark:** *HAMPSHIRE/ POTTERY/98* **incised on bottom. Gift of Mary and Paul Brandwein**

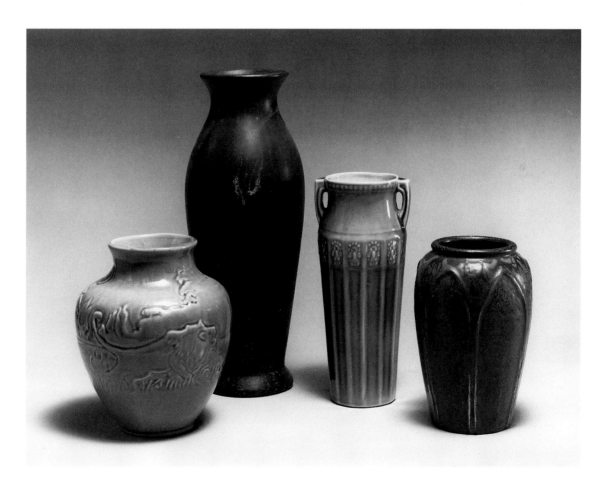

gory produced figures in the Art Deco style, but Schreckengost, Winter, and Aitken worked in the newer Viennese style and developed a new attitude toward clay that would supersede the art pottery aesthetic during the 1930s.

Cowan did produce vessels that rightfully can be termed art pottery, and are typical of the wares produced toward the end of the era. They are mold made, simple and classic in form, and elegantly glazed. One-of-a-kind vessels were also made, modeled by Richard Hummel and by Cowan himself. Luster ware and crackle ware were popular, and company catalogues indicate the wide variety of forms available to the public. The wares were sold in prestigious shops across the country. But like so many other art potteries, the Cowan manufactory fell victim to the Great Depression, and its doors were closed in 1931.

Cowan then became art director for the Onondaga Pottery Company, now Syracuse China Corporation, in New York. While in Syracuse, he became involved in the Syracuse Museum of Fine Arts, now the Everson Museum of Art, and was instrumental, along with Anna Olmsted, the director of the museum, in the establishment of the Ceramic National Exhibitions, for which the Everson is well known. The Ceramic Nationals continue today, and it was from these exhibitions that the Everson collection, one of the finest in the country, was formed.

Adelaide Alsop Robineau

Adelaide Alsop Robineau is an enigma in the history of American ceramics. Robineau, whose work spans the entire art pottery era, created some of the finest ceramics ever produced in this country. Like so many other women in the movement, she began as a china painter, opened her own pottery, and made production wares to supplement her own work. But unlike others, who became more involved with the commercial aspects of pottery production, Robineau soon abandoned the commercial side of her venture and concentrated on her own handmade wares. She was one of the few art pottery figures to move into the realm of the studio potter.

Robineau was a china painter and teacher of the process when, with the financial backing of her husband, Samuel, she established *Keramic Studio,* a magazine for china decorators. This was a publication aimed particularly at educating its readers in both the technical aspects of overglaze painting and aesthetic matters. The magazine was very successful, and became a handbook for American ceramists and teachers of design for many years. The magazine helped to finance her studio work. The name of the magazine changed to *Design* after 1924.

Robineau had planned to support her work by operating a production pottery in her studio in Syracuse. She assembled the required equipment, materials, and assistants, but the venture was short-lived. The production wares were to consist of doorknobs, drawer pulls, and various other useful items. Either because of market disinterest or because of Robineau's own disenchantment with repetitive work, production ceased after only a few months. In all, only a few were made, which are now finding their way into both private and

museum collections. With the encouragement and help of Samuel, Robineau now pursued her own work in porcelain.

She seemed to thrive on challenges. She had little training in porcelain production (she spent a few weeks at Alfred, her only formal training in ceramics), but she read everything she could find on the subject. Samuel, a Frenchman, translated Taxile Doat's treatise on *grand feu* firing, and this detailed description of the technique of porcelain making was the basis of her experiments. Unlike the French, who had been producing exquisite porcelains for many years, Americans had no porcelain tradition, and so Robineau was left to her own experiments in creating clay bodies and appropriate glazes. She tried to use American materials, which added to her difficulties, for the clays were much less forgiving, and more difficult to form than the European materials. She taught herself to throw on the wheel, though she must have often turned her pieces, which was common among ceramists at the time.

Always eager for a new adventure in ceramics, Robineau worked in a wide variety of ways. Some forms are simple, with exquisitely complicated glazes, while others are intricately excised. Some have themes, while others are enjoyed solely for their aesthetic qualities. She was influenced by contemporary English and French work, and also by the ancient Chinese and Mayan civilizations. Robineau left a body of work that is at once classic and extraordinarily experimental.

Her earliest pieces were exhibited in 1901.[33] In 1902 she gained access to the information in the Doat treatise, and within a very short time she had mastered her materials, for in 1904 she exhibited at the St. Louis World's Fair. By 1905 Tiffany was selling her work. These pieces were all produced at her studio adjacent to her home in Syracuse. In 1910 she was invited by Edward G. Lewis, founder of the American Women's League, to join the faculty of his proposed University City Pottery in St. Louis, Missouri. This venture was a part of a correspondence school dedicated to "the integrity and purity of the American home, with wider opportunity for American women." While most of the learning was done through the correspondence courses, it was envisioned that in the ceramics section women with extraordinary ability would be invited to study at the pottery under the tutelage of the staff.

Considering the kind of environment she fostered in her home, and the modern approaches she took to education, it is not surprising to read Robineau's commentaries in *Keramic Studio* and learn that such an invitation would be appealing to her. She was a feminist ahead of her time. When she designed her studio, for example, arrangements were made to set up a playroom for her children above the pottery so they could be close to their mother while she worked, which was then highly innovative. Her home, in the Arts and Crafts style, was designed by a woman, New York architect Katherine Budd, a graduate of Columbia. Robineau encouraged her daughters to pursue independent careers, and saw that they were educated in such a way that would enable them to do so. She conducted summer school classes for women at her studio in Syracuse, and provided child care in the form of classes and activities for children of the women who attended so they

could accompany their mothers. She wrote about "the domestic problem," as she called it, in *Keramic Studio,* noting that women must be relieved of some of the tiresome aspects of household activities and child care if they were to be able to pursue personal fulfillment.

One would think, then, that this modern-thinking woman would create objects in an avant-garde style, but such was not really the case. While many of her works do reflect her interest in the Arts and Crafts movement, many do not, or at best are impossible to categorize stylistically. But this only serves to accent her individual genius. She did not limit herself to any single style or working method. Her only pursuit was perfection.

At University City, she worked with her mentor, Taxile Doat, who had been imported from France to add the luster of the Sèvres name to the faculty in St. Louis. She had looked forward to this contact with the great ceramist, hoping to learn more of his techniques. But she was to be disappointed, for the Frenchmen (there were two others in his entourage) spoke no English, and were quite secretive about their work. In fact, upon looking at the work done at the pottery, one wonders if perhaps the Frenchmen learned as much from Mrs. Robineau as she might have learned from them.

It was at University City that Adelaide created her tour de force, the famous *Scarab Vase,* also called *The Apotheosis of the Toiler.* The scarab motif, an ancient Egyptian device referring to rebirth and creative powers, covers the surface of the piece, with three central medallions of radiating scarab motifs. The motif is repeated on the carved lid and base, both pieces separate from the vessel itself. This incredible vase is carved in what appears to be a double-wall technique that was first used by ancient Chinese potters. Actually, Robineau simply made the wall of the vase thicker in the carved areas, and excised the design with a slight undercutting which gives the illusion of a double wall with space in between. It is said that the carving of this piece took over one thousand hours.

The tools of the potter are as personal as those of any other artist, and good modeling tools are difficult to acquire. Robineau was as resourceful in acquiring the right tools as she was in acquiring the correct methods of working. Frederick Hurten Rhead, who worked with her at University City and who was a lifelong friend, reported that she used dental and surgical instruments, piano wire, tapestry needles, and engraving and wood-carving tools.[34] Her work was so delicate and fragile that it was imperative that she have the right tools for each job.

Robineau experimented with glaze colors for the vase, and finally settled on a combination of white and a gentle turquoise. Subtlety was the name of the game. The results were astounding. The *Scarab Vase* is majestic and exquisitely complex, yet simple, understated, and reserved. It is probably the most widely known piece of American ceramics.

The vase has a varied and interesting history. Upon opening the kiln after the firing of the piece, Robineau discovered some severe cracks at the bottom of the vase. One can imagine the distress she must have felt, but in her determined way, she decided to repair the piece by filling the cracks with ground porce-

Adelaide Alsop Robineau.
MONOGRAM VASE. 1905.
Porcelain, H. 12¼, Diam. 5".
Mark: conjoined *AR* in a circle
excised; *141* incised, both on
bottom. Museum purchase

*The restrained color and simplicity
of stylized decoration place this vase
squarely within the Arts and Crafts
style.*

lain and glazing them with the same glaze she had originally used. Doat advised her against such an action, and suggested she simply fill the cracks with paste and enamel them to match the glaze. Robineau "laughed at that suggestion and said she would either repair the vase at high fire or throw it in the ash can."[35] The vase was fired a second time and emerged from the kiln in pristine condition. Although the piece had been intended for the American Women's League, it was returned to the Robineaus due to financial difficulties at the league. It was later purchased by the Syracuse Museum of Fine Arts, now Everson Museum of Art, along with forty-three other Robineau porcelains, including the *Lantern* (which had been declined by the Metropolitan Museum of Art), the *Viking Ship Vase,* the *Crab Vase,* the *Poppy Vase,* and the *Monogram Vase,* for four thousand dollars. In 1989 thieves absconded with the *Scarab,* but naively tried to dispose of it, along with a number of objects purloined from several other museums, in New York City. Fortunately, the celebrity of the piece proved to be their undoing, and the vase was returned to the museum.

Robineau used many techniques in the production of her wares. The *Scarab* is excised, as is her *Lantern, Turtle Vase,* and *Crab Vase,* but these pieces are also reticulated as well. She was never one to set herself an easy course. Her glazes ranged from flambé to the most crackly crystallines, deeply colored mattes, and thickly flowing pastels. They are by turns painterly and flatly colored. Sizes range from a few inches to nearly two feet.

Unlike most of the art potters and potteries of the day, Robineau was not satisfied to achieve mastery of a technique and then settle back and reproduce that product over and over again. Once she had mastered something, she, like Leonardo, went on to the next challenge. Her earliest successes, illustrated in *Keramic Studio,* were with crystalline glazes. Within a very few years, she went on to produce the remarkable *Viking Ship Vase.* The carving on this piece has been carefully rounded and smoothed, leaving soft contours on both the shoulder decoration and on the ring base. The contours are softened even more by the glaze, which flows and blends across the piece, leaving a soft matte surface that echoes the colors and action of the ocean. Robineau has reached the point where she can use her technical expertise in glazing to achieve specific intended aesthetic effects.[36]

By contrast, the carving on the *Scarab Vase* is sharper, leaving a more clearly defined design, which is softened somewhat by the thickness of the glaze. The glaze on this piece was carefully applied with a brush, for it had to be contained within specific areas, without running. The *Scarab* also has an all-over repetitive pattern, creating a textured surface that is accented by the three medallions. Robineau employed a similar all-over pattern again later in her ill-fated *Turtle Vase,* which partly collapsed during firing. Here the medallion motif has been used within vertical ribbons which are crossed by freely meandering seaweeds. The medallions give a sense of stability, while the movement of the seaweed suggests the slow, gentle motion of underwater currents. This vase has a soft green and blue coloration. The medallions are excised, and portions of the background are reticulated, adding to the delicacy of the form.

Robineau used both excised areas and reticulated areas in her *Lantern* as well. This form was inspired

Adelaide Alsop Robineau. **Maquettes for** Scarab Vase. **c. 1910.** Left: **Porcelain, H. 1⅜, W. 1½, D. ⅛". Mark:** *Scarab Vase-Robineau* **on back in blue. Museum purchase with funds from Mr. and Mrs. Michael J. Falcone.** Right: **Porcelain, H. 3, W. 1⅞, D.¼". Mark:** *Scarab Vase* **on back in blue. Museum purchase with funds from Mr. and Mrs. John S. Dietz**

It is evident from these glaze trials that Robineau at first considered the **Scarab Vase,** *with its stylized beetle motif, to be in the Arts and Crafts style. The browns, beiges, and turquoise color would have given the piece a heavy, restrained look. Fortunately, she chose a lighter, more subtle scheme, which resulted in a more classic look, with Oriental overtones.*

**Adelaide Alsop Robineau.
SCARAB VASE (THE APOTHEOSIS
OF THE TOILER). 1910. Porcelain.
H. 16⅝, Diam. 6". Mark:
conjoined *AR* in a circle excised
on bottom;** *THE APOTHEOSIS
OF THE TOILER. 60; 1910' MADE
FOR THE U.C. WOMEN'S
LEAGUE* **incised on bottom,
conjoined *AR* incised on under-
side of lid; conjoined *AR* in
circle and** *1910, U.C.* **incised on
underside of base. Museum
purchase**

*If one piece signifies the most
spectacular accomplishment of the
period, it is Robineau's* Scarab Vase,
*extraordinary for its detail, scale, and
subtle coloration.*

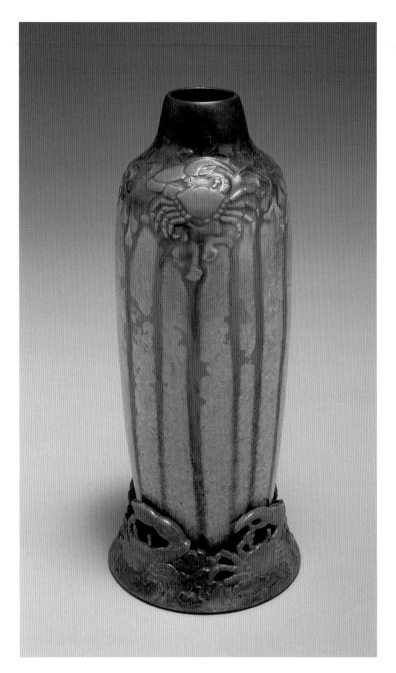

Adelaide Alsop Robineau. CRAB VASE, 1908. Porcelain, H. 7⅛, Diam. 2½".
Marks: conjoined *AR* in a circle excised; *571* incised—both on bottom; on
inside of ring base: incised cipher of conjoined *AR*. Museum purchase

Adelaide Alsop Robineau. POPPY VASE. 1910. Porcelain, H. 6,
Diam. 3¾". Mark: conjoined *AR* in a circle excised; *O.U.C.*
and *1910* incised—all on bottom. Museum purchase

Adelaide Alsop Robineau.
LANTERN. 1908. Porcelain, H. 8,
W. 6". Mark: conjoined *AR*
incised; *1908* and *668* excised—
both inside vessel. Museum
purchase

*Though this lantern was directly
inspired by a Chinese piece in the
Metropolitan Museum of Art,
Robineau added stylized motifs
which bring the piece into the realm
of the Arts and Crafts style.*

by a very similar Chinese lantern of the K'ang Hsi period in the collection of the Metropolitan Museum of Art in New York. Robineau had published a photograph of it in *Keramic Studio,* so we know that she was aware of the piece. But she refined the original form, creating a less flamboyant version, and substituting Arts and Crafts imagery for Chinese motifs. The bottom section is excised, leaving a solid inner wall to hide the candle that the lantern would have held. The upper portion is pierced to allow the light to escape. Robineau considered this her best work up to that time (the *Scarab* vase would not be accomplished for another two years), and it was hailed by the art pottery cognoscenti of the period, including William Grueby and Robineau's mentor, Taxile Doat.

Robineau preferred excising and reticulation to incising, but one piece decorated in this manner illustrates that she was proficient in this method as well. The *Poppy Vase* was created by carefully carving out the decorated sections and filling the indentations with colored slips. The surface of the clay was then smoothed, and the piece bisque-fired. A transparent glaze was then applied and given a final firing. The result is likened visually to cloisonné.

The *Cinerary Urn* was Robineau's last piece and at the time of her death it was unfinished. Preliminary drawings of the urn reveal that Robineau had planned a frieze about the central section of the piece which would have consisted of a series of female nudes surrounded by swirling flames. This section was never accomplished, and instead remains a plain area. The piece was glazed to Robineau's specifications by Carlton Atherton, whom she considered to be her best student. The urn is now in the collection of Everson Museum of Art, and contains the ashes of Mrs. Robineau and those of her husband.

Adelaide Robineau was the most accomplished figure of the art pottery period. Maria Longworth Nichols used her wealth to promote a product to bring beauty to the masses, but it could not equal that created by Robineau. Mary Louise McLaughlin experimented with porcelain, but never achieved the heights of perfection for which Robineau strived. Mary Chase Perry Stratton operated a successful tile business, but her aesthetic sensibility was entirely different from that of Robineau. Even Albert Valentien, Frederick Hurten Rhead, and Louis Comfort Tiffany could not approach her technical expertise nor her sense of elegance and refinement. She moved American ceramics into the studio pottery era. Adelaide Robineau's work remains the benchmark in American ceramics.

Adelaide Alsop Robineau. VASE. 1905. Porcelain, H. 8½, Diam. 3".
Mark: conjoined *AR* in a circle excised on bottom. Museum purchase

LEFT: Adelaide Alsop Robineau. VASE. 1910. Porcelain, H. 11½, Diam. 2¾".
Mark: conjoined *AR* in a circle excised on bottom; *1910 11 UC*
incised on bottom. Museum purchase

*This remarkable vase, with its thick flowing glaze, has a thin, wide lip with a
subtly delicate crystalline glaze that contrasts gently with the surfaces below.*

OPPOSITE: Pewabic Pottery. Mary Chase Perry Stratton. MONUMENTAL VASE.
n.d. Earthenware, H. 25, Diam. 14½". Mark: none. Anonymous gift

*Perry was known for her exquisite glazes, including the elegant iridescent
glaze which covers this monumental vase.*

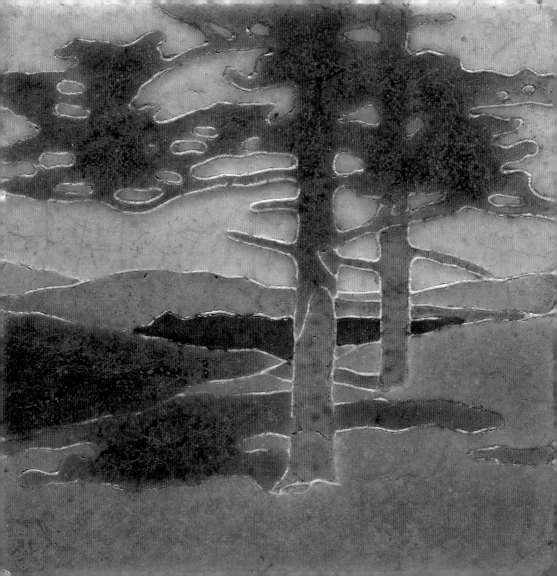

AMERICAN TILES OF THE ART POTTERY ERA

The growth of the American art tile industry coincides with that of the American art pottery movement, but, with a few exceptions, art tiles should be regarded as a separate entity. In most cases, the manufacture of art tiles was not carried on by art potteries, although the two movements are related stylistically. The sudden and energetic enthusiasm for art tiles in the United States was mirrored by a similar interest worldwide. Mass production allowed tiles to be produced much more economically than before, making them affordable to a wider market. The Gothic revival engendered great interest in paving tiles, and sanitation laws encouraged tiled interiors (and exteriors) in hospitals, breweries, dairies, butcher shops, kitchens, and bathrooms. Tiles were also used extensively in the new tunnels and underground railways being built both here and abroad. Soon the public realized the decorative possibilities of tiles, and they became popular adjuncts to the home. The market was growing by leaps and bounds.

England was a major producer during the nineteenth century, and most tiles found in the United States prior to about 1880 are of English origin. When American tile manufacturers initiated their production, they looked to England not only for methodology, but also for workers. Many experienced pottery and tile makers in England emigrated to America during this period, seeking work and opportunity. As a result, the production of tiles in America mirrored that in England. American Encaustic Tile Company, established in 1875 in Zanesville, Ohio, initially made encaustic tiles. This method of tile making dates to the Middle Ages. The decoration on the tile is created by inlaying colored clays; this inlay resulted in greater wearability and preservation of the actual design. Encaustic tiles are very useful for floors and stairways, areas of high traffic, and are easy to mass produce.

The period from 1875 to 1895 saw the establishment of the major tile producers in America: AETCo, just mentioned, and Mosaic Tile Company (both of Zanesville); United States Encaustic Tile Co. (Indianapolis, 1877); the two Low tile companies (1878 and 1883, Chelsea, Massachusetts); Trent Tile Works (Trenton, New Jersey, 1882); Providential Tile Works (Trenton, 1886); and Beaver Falls Tile Company (Beaver Falls, Penn-

Grueby Faience. Addison Le Boutellier, designer. LANDSCAPE TILE, c. 1905. Earthenware, 6" square. Mark: partial paper label on front reads: *Grueby Pottery/* **logo/***Boston U.S.A.* **Gift of Mary and Paul Brandwein**

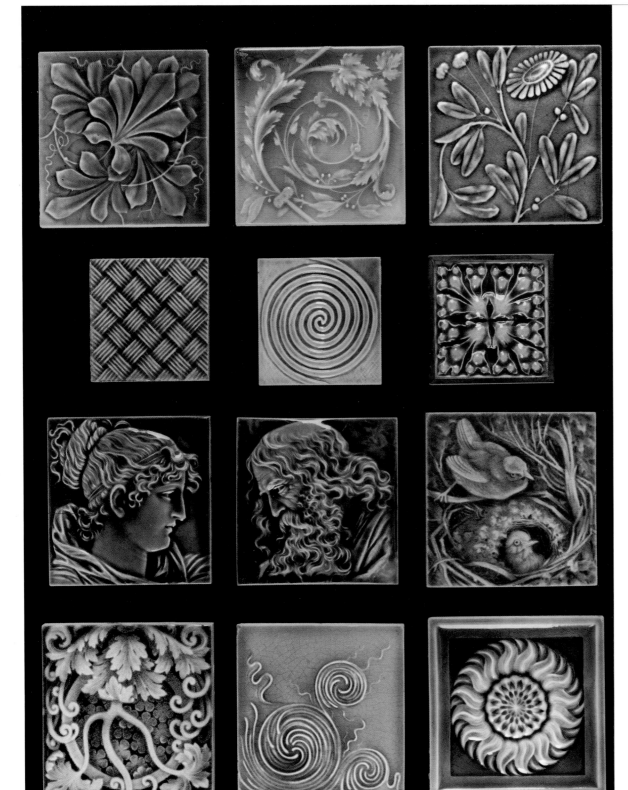

TOP ROW, LEFT TO RIGHT: **Group of Victorian Tiles.** Kensington Art Tile Co. RELIEF TILE. Earthenware, 6" square. Mark: *Kensington* on back in relief. Gift of Mary and Paul Brandwein. C. Pardee Works. TILE WITH SPIRALING VINE. 1892–1920. Earthenware, 6" square. Mark: *The C. Pardee Works* in relief on back, with *2.* Gift of Mary and Paul Brandwein. J. and J. G. Low Art Tile Works. RELIEF TILE WITH DAISY. 1878–1902. Earthenware, 6" square. Mark: *J.& J. G. LOW*/crossed keys cipher/*PATENT ART TILE*/*WORKS*/*CHELSEA MASS.* in relief on back. Gift of Mary and Paul Brandwein

SECOND ROW, LEFT TO RIGHT: J. & J. G. Low Art Tile Works. TILE WITH BASKET WEAVE PATTERN. 1878–83. Earthenware, 4½" square. Mark: *J. & J. G. LOW*/*PATENT ART TILE* /*WORKS* /*CHELSEA* /*MASS.* /*U.S.A.* / *copyright J.& J. G. Low,* impressed on back. Gift of Mary and Paul Brandwein. J. & J. G. Low Art Tile Works. TILE WITH SPIRAL. c. 1882. Earthenware, 4¼" square. Mark: *J.& J. G. LOW*/*PATENT ART TILE*/*WORKS*/*CHELSEA*/*MASS*/*U.S.A.*/*COPYRIGHT 1882 J.& J. G. LOW* impressed on back. Gift of Mary and Paul Brandwein. J. & J. G. Low Art Tile Works. HIGH RELIEF TILE. 1878–83. Earthenware, 4¼" square. Mark: none visible. Gift of Mary and Paul Brandwein

THIRD ROW, LEFT TO RIGHT: **Providential Tile Works, attributed to Isaac Broome. TILE WITH PROFILE OF A WOMAN. 1886.** Earthenware, 6" square. Mark: none. Gift of Mary and Paul Brandwein. Providential Tile Works. Isaac Broome, designer. TILE WITH HEAD OF A BEARDED MAN. 1886. Earthenware, 6" square. Mark: none. Gift

of Mary and Paul Brandwein. **Providential Tile Works, attributed to Isaac Broome. Tile with Bird in Nest.** Before 1900. Earthenware, 6" square. Mark: *010/THE PROVIDENTIAL/TILE WORKS/ TRENTON. N.J./COLOR.* on back. Gift of Mary and Paul Brandwein

Fourth row, left to right: **Trent Tile Co. Tile with Vines and Foliage.** Before 1900. Earthenware, 6" square. Mark: *TRENT TILE/TRENTON. N.J./U.S.A.* impressed on back. Gift of Mary and Paul Brandwein. **Trent Tile Co. Border Tile.** c. 1890. Earthenware, 6" square. Mark: none. Gift of Mary and Paul Brandwein **J. & J. G. Low Art Tiles. Tile with Sun Motif.** 1881. Earthenware, 6¼" square. Mark: *J. & J.. LOW/ PATENT ART TILE WORKS/ CHELSEA/MASS. U.S.A./ COPYRIGHT 1881 BY J.& J. LOW* impressed on back. Gift of Mary and Paul Brandwein

sylvania, 1886). These were followed by several others each year, and by the art potteries themselves who began to produce tiles as a part of their art wares (Rookwood, Owens, Newcomb, Weller, Overbeck, and Marblehead, for example).

Besides encaustic tiles, the Victorian relief tile with a high-gloss glaze became a favorite with the public. These tiles served many purposes. They could be used on the wall, as a border or dado, on the ceiling, to surround fireplaces, decorate iron stoves and pieces of furniture, or hang on the wall as plaques, often framed. Sometimes the motifs were purely decorative, and sometimes they were figural. There were favorite figures: historical (particularly in Medieval or Renaissance costume), mythological, literary, or allegorical. Shakespearean characters were popular, as were figures representing the four seasons, the arts, the signs of the zodiac, philosophers, and children. And in keeping with the tastes of the times, themes from nature abounded, as they did on the surfaces of the vessels being produced by the art potteries. Floral, leaf, and landscape motifs appear in profusion on tiles.

The Victorian relief tiles depicted a figural or decorative motif raised against the background, which were usually covered with a high-gloss glaze of a single color. The glaze would pool in the deeper areas, creating darker areas of color, while the raised areas would receive only a thin covering of glaze, leaving a highlighted area. Thus, there was a nice contrast between the lights and darks which added the illusion of greater depth to the piece. These Victorian tiles are analogous to the early underglaze slip-painted art wares produced by Rookwood, Weller, Owens, and the many other potteries who were imitating Rookwood Standard ware. Both are glazed with a high-gloss glaze, both have a textured surface, and the colors used by each are similar, for browns and ochers were favorites of the tile makers as well as of the art potteries. Both the tile makers and the art potteries referred to nature for themes. These relief tiles were made to be enjoyed as single examples, or, more often, designed to work as sets to create a continuous border or an allover pattern. Sometimes the single examples would be incorporated into a stove, piece of furniture, or used as an accent in an otherwise plain tile installation. Sometimes they were to be enjoyed for their own sake, as the large tile depicting the story of Atalanta. But no matter what their use, the motifs were always presented in a realistic fashion, seldom with stylization. This was also in keeping with the practices at the art potteries at this time.

Intaglio was also used to produce pictorial tiles. With this method, the motif is impressed into the tile, the opposite of relief decoration. The tile is then glazed, usually with a monochromatic gloss glaze. As on the relief tile, the glaze gathers most deeply in the recessed areas and lies in a thinner layer on the higher areas, creating a variety of tones. In this way, very subtle gradations of tone can be achieved by carefully graduating the depth of the impression. The surface has a very slight texture because of the pooling of the glaze. This method was ideal for portraiture, as can be seen in the C. Pardee Company tile depicting Grover Cleveland.

The most common decorative process used in England was transfer printing, or decalcomania. American tile companies adopted this method, for it was easy and inexpensive. A transfer print (or decal, as Amer-

icans call it) is made by impressing a design on a sheet of tissue paper. The design is then transferred to the surface of the vessel or tile, which has been biscuit-fired. It is then fired again, and any color or further decoration can be added before a final glazing and firing. The design tissues could be made by the pottery, or they could be purchased, resulting in the same motif being produced by more than one tile maker.[37] For instance, American Encaustic Tile Company and Mosaic Tile Company made identical tiles decorated with illustrations by Walter Crane. Crane's illustrations were very popular both here and abroad, and served as inspiration for a number of American-produced tiles, particularly those produced by AETCo and Mosaic. The illustrations of Kate Greenaway were also popular, and her style was imitated here as well.

As its name implies, American Encaustic Tile Company initially produced encaustic tiles. But soon the company realized that other methods could also prove profitable, and by 1880 they were making glazed tiles, and in 1881 began to produce embossed tiles.[38] Business was good, and soon the company had grown to become the largest tile works in the world.[39] As one can imagine, the variety of tiles produced was enormous, and it is nearly impossible to identify a single "look" to attribute to AETCo tiles. They made encaustic, glossy-glazed relief, and transfer-printed tiles. Styles range from Beaux-Arts to Art Nouveau and Arts and Crafts.

AETCo produced tiles for both interior and exterior use. Floor and architectural tiles were made, as well as fireplace surrounds, mantles, hearths, bathroom tiles, and border tiles. Its architectural tiles were of very high quality, and were chosen to line one-half of New York's Holland Tunnel. The company also produced souvenir items (as did many potteries) and advertising tiles and figures. It also made bookends, small figures, ashtrays, and boxes.

Because of its location in the largest clay-working region in the country, AETCo attracted many well-known artists and designers, some of whom also worked at other potteries as well, which was typical of decorators and designers in the art potteries. The most important of the early designers was Herman Mueller. Like other adherents to the ideals of the Arts and Crafts movement, Mueller believed that "the artist and the artisan are not so far apart as some people imagine."[40] Mueller believed that ceramics should be artistic as well as decorative and useful. Born in Germany into a family of craftsmen, Herman attended the Nuremberg School of Industrial Arts and then moved on to the Munich Academy of Fine Arts, where he studied sculpture. He emigrated to America in 1878 and settled in Cincinnati in 1879, where he became a modeler at the Matt Morgan Art Pottery. In 1885 he worked for the Kensington Art Tile Company in Newport, Kentucky, a short-lived operation that produced sculptural tiles, usually with gloss-glazed surfaces. Mueller then became a modeler for American Encaustic Tile Company in 1887.

With the arrival of Mueller, the artistic quality of AETCo tiles improved immensely. He created a large number of relief tiles, some individual, some multi-tile panels. He had a Beaux-Arts style, and his work reveals the influence of the stove tiles he would have been so familiar with in his native Germany. He was partial to classical and Renaissance themes, which worked particularly well with his sculptural style. He and the ceramic

Clockwise, from top right: **Group of Art Tiles. American Encaustic Tile Co. WILLIAM MCKINLEY. c. 1901.** Earthenware, 3" square. Mark: *AMERICAN/ENCAUSTIC TILING CO./LTD./NEW YORK/AND/ZANESVILLE O.* impressed on back. Gift of Mary and Paul Brandwein. **American Encaustic Tile Co. Christien Nielson, designer. GROVER CLEVELAND. 1894–1902.** Earthenware, 3" square. Mark: *American Encaustic Tiling Co. Ltd. New York and Zanesville O* impressed on back. Artist's monogram CN on face of tile at lower right. Gift of Mary and Paul Brandwein. **Mosaic Tile Co. ABRAHAM LINCOLN. c. 1917.** Earthenware, H. 3½, W. 3, D. 1". Mark: Mosaic Tile Co. cipher, with *TRADE MARK The Mosaic Tile Company Zanesville Ohio,* all in relief on back. Gift of Mary and Paul Brandwein. **GENERAL JOHN PERSHING. c. 1917.** Earthenware, H. 5¼, W. 3½, D. 1". Mark: *Zanesville/Post No. 29/American Legion/Home/Building Fund/Mfg. by/The Mosaic/Tile Co./Zanesville/ Ohio* in relief on back. Gift of Mary and Paul Brandwein. **C. Pardee Works, C. Nielson, designer. GROVER CLEVELAND. 1893.** Earthenware, 6" square. Mark: none. Gift of Mary and Paul Brandwein

chemist Karl Langenbeck (who had previously been associated with Rookwood Pottery) collaborated on producing intaglio tiles, which proved to be very popular. The Brandwein Collection contains several tiles designed by Mueller, including a large ocher relief panel depicting a youth (perhaps David) in classic garb holding a lyre, and an example of the tile designed to commemorate the dedication of an addition to the factory. The delicate tile depicting the race between Atalanta and Hippomenes is also attributed to Mueller. Mueller's tenure at AETCo is associated with the relief and intaglio tiles and plaques with monochromatic gloss glazes that were so popular up to the turn of the century.

In 1917 Frederick Hurten Rhead joined the staff at AETCo as a designer, but soon became director of research.[41] He was responsible for the formulation of clay bodies and glazes for the tiles, and designed many of the tiles produced during this period. His organizational skills also helped to keep AETCo one of the largest and most efficiently operated manufactories in the country. During his tenure there the production of tiles with illustrations by Walter Crane was revived.

Other important men worked at AETCo over the years. Leon Solon came to America in 1909 from England, where he was art director at Minton. The Art Deco works produced at AETCo about 1925 are attributed to him, since he worked in the Secessionist style at Minton.[42] Karl Bergman, a Belgian, designed for AETCo for two and a half years. He was educated at the Royal Academy of Brussels. Harry Northrup also worked as a designer, as did Christien Nielson, who later worked for Roseville Pottery.

When Herman Mueller left AETCo in 1894, he took with him Karl Langenbeck. Together, the two men founded the Mosaic Tile Company, also in Zanesville. They both concentrated on the technical aspects of production, with Langenbeck concentrating on chemical concerns of production and Mueller inventing new processes and products. The "mosaic" process resulted in a true encaustic tile, with the color in the body of the ware and the designs created from small tesserae placed on a larger tile. This method was used for producing murals, and many were completed for churches, government buildings, hotels, and commercial buildings. The manufactory grew quickly, and branch offices were established on both the East and West coasts. The Everson collection has a number of Mosaic Tile Co. pieces, including one depicting an Aztec figure (Pre-Columbian motifs were popular at this time), and small portrait tiles of Abraham Lincoln and General John Pershing.

Mueller and Langenbeck became disenchanted with the company when the directors took a more commercial approach to production,[43] and went their separate ways. Mueller took a job for a short time at the Robertson Art Branch in Morrisville, Pennsylvania, and in 1908 established his own company, Mueller Mosaic Company, in Trenton, New Jersey. Mueller concentrated on art tiles, and worked closely with architects to design installations for building interiors and exteriors. He was intensely interested in education, and served as president of the Trenton Board of Education. He was also a musician and sang with local singing groups. (As a boy he had aspired to be an opera singer.)[44] Mueller was very much a part of the Arts and Crafts

OPPOSITE: **American Encaustic Tile Co. SUNFLOWER FIREPLACE SURROUND. c. 1880. Earthenware, 5 tiles, each tile 6" square. Mark: none. Gift of Mary and Paul Brandwein**

Fireplace surrounds were popular in Arts and Crafts–style homes. Sometimes the tiles were used around all three sides, or they could be used only across the top of the opening.

BELOW: **American Encaustic Tile Co., Herman Mueller, designer. TILE WITH ATALANTA AND HIPPOMENES, 1886–93. Earthenware, 6 x 18". Mark: none visible. Gift of Mary and Paul Brandwein**

This tile tells the story of the race between Atalanta and Hippomenes, which Atalanta loses because she stops to retrieve the golden apples dropped by Hippomenes.

movement, and his belief in the collaboration between man and machine placed him within the American strain of that aesthetic.

Some of the finest tiles of the period were produced by the Low tile companies of Chelsea, Massachusetts. The earliest of these family-owned works, established in 1878, was called the J. & J. G. Low Art Tile Works. The firm became J. G. & J. F. Low in 1883 when John, the father of John Gardner Low, retired and J. G.'s son, John F., joined the firm. John Gardner had worked at the Chelsea Keramic Art Works, and George Robertson, brother of the Chelsea owners, joined him in the new venture. Arthur Osborne, an Englishman who was trained in the sculptural tradition of his native country, was hired as designer and artistic director. Osborne concentrated on design, and Robertson contributed the glazes, drawing on many years of family tradition.[45]

Low eschewed the printed tiles so widely produced at the time in favor of relief tiles and, in a departure from American methods of design, of tiles impressed with various objects from nature: leaves, grasses, buds, and even pieces of woven fabrics. These were glazed with a monochrome gloss glaze to accent the relief, much like the tiles of AETCo. The motifs and the compositions of these impressed tiles reflect Japanese influence and the mania for things Japanese that was sweeping America (and Europe) at the time.

John Gardner Low and his father were close friends with Edward Morse, who had lived and worked for many years in Japan, and who had brought a collection of over five thousand pieces of Japanese pottery with him when he returned home to Salem, Massachusetts. The Lows corresponded, visited, and traveled with Morse, including a trip to Rookwood Pottery in 1888. Low would have had easy access to examples of Japanese ceramics in the Morse collection, which includes pieces decorated with impressions of grasses and other natural objects. Specifically, then, the use of sea creatures, cranes, bamboo, and Japanese-like patterning in the

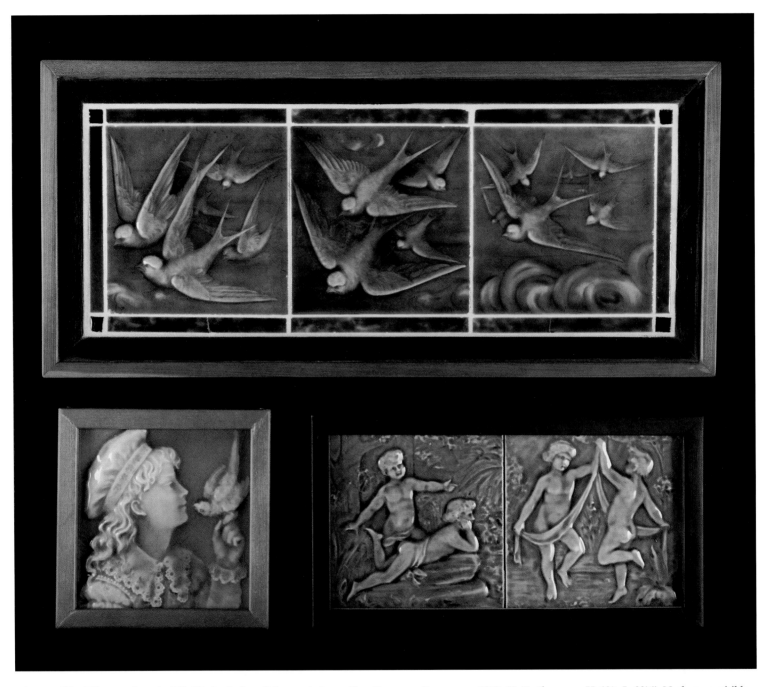

Group of Art Tiles. Top: **Low Art Tile Works. Arthur Osborne, designer. TILE SET WITH SWALLOWS. 1879–93. Earthenware, H. 10½, L. 22¼". Mark: none visible.
Gift of Mary and Paul Brandwein** Bottom left: **Trent Tile Works. Isaac Broome, designer. TILE WITH BOY HOLDING BIRD, 1883–86. Earthenware,
6" square. Mark:** *TRENT* **in relief on back. Gift of Mary and Paul Brandwein.** Bottom right: **Kensington Tile Co. Herman Mueller, designer.
TILE SET WITH CHERUBS, 1885–86. Earthenware, each tile 6" square. Mark:** *HM* **on front at lower right corner. Gift of Mary and Paul Brandwein**

Low tiles could have had as their source the ceramics and other objects brought from Japan by Morse.

The Japanese craze had also stimulated businesses that catered to the preference for things Japanese. Shops carrying Japanese art objects opened in most cities, particularly along the coast, where trade with the East was a tradition. The Japanese themselves opened import shops in New York. Morse was not the only one to collect Japanese objects, for this was the era during which the large Asian collections in this country were initiated. Even Maria Longworth Nichols had a large collection of Japanese art, including pottery, which she made available to the designers and decorators at Rookwood (practically every art pottery in America produced at least some works to appeal to the market that preferred the Japanesque). It would have been very easy for the Lows to have access to all kinds of Japanese products.

Low Art Tile Works produced a wide variety of tiles during the period. Designs range from simple, undecorated tiles with exquisite glazes and relief tiles that create a textured surface, to figural tiles, mantle friezes, tile sets, panels for clocks and other objects, and souvenir tiles. They were both molded and hand modeled. The initials AO indicate a tile was created by Arthur Osborne, who created both the molds for tiles and hand modeled some pieces.

Isaac Broome is remembered mainly for his *Baseball Vase* of 1876, but he was also a china painter[46] and a prolific designer of tiles. He became the first designer for Trent Tile Co. in Trenton, New Jersey, in 1883. Broome created relief tiles in the traditional manner, usually glazed with a monochromatic gloss glaze. Trent Tile produced well-designed tiles using natural motifs popular at the time, and figural tiles. The sensitive rendering of a young boy in a historic costume with a bird on his finger, now in the Brandwein Collection, was done by Broome while at Trent.

Broome left Trent in 1886 to help establish Providential Tile Works, also in Trenton. There he continued to model figural tiles and tiles with natural motifs, all in relief and with the ubiquitous monochrome gloss glaze. His tile depicting the head of a bearded man is indicative of his style. Providential also produced stove tiles and plain as well as relief tiles. A tile depicting a mother bird and baby in a nest may also have been designed by Broome. It has a soft green glaze that enhances the detail of the relief design. Broome moved again, this time in 1890 to Beaver Falls Art Tile Co. in Beaver Falls, Pennsylvania, north of Pittsburgh. There he continued to design figural tiles.

With the growth of the Arts and Crafts movement in this country, tiles, like pottery, took on a different look. Just as the art potteries abandoned the dark glossy surfaces of their slip-decorated wares and opted for a matte or vellum surface, so tile companies turned to the matte-glazed tile. Flat, conventionalized designs replaced the naturalistic reliefs so popular just a few years before. Epitomizing this look are the tiles of William H. Grueby's pottery in Boston, Massachusetts.

Grueby had worked for Low Art Tile Works as a young man and in 1894 established his own firm, the Grueby Faience Co. in Boston, Massachusetts, where he produced architectural faience and art pottery. He

used native clays from New Jersey and Martha's Vineyard, whose heavy, grogged bodies resulted in very thick tiles, unlike those produced by the larger commercial enterprises. His glazes, recognized for their quality internationally, were matte, with subtle, subdued colors which blended perfectly with the prevailing Arts and Crafts style.

Designs were stylized, or "conventionalized" (the preferred word of the period), and were in the fashion of the Symbolists, with flat, outlined areas of color. There is a slight surface texture to these tiles, since the outlining was done with a squeeze bag, leaving ridges between which the glazes were added. The firm made individual tiles, which were often framed for hanging, as well as friezes used as fireplace surrounds, borders, and accents. There are ships, landscapes, animals, flowers, religious symbols, historical figures and beasts, fruits, and a myriad of other subjects.

An often-overlooked aspect of Grueby tile production are the large tile installations in the New York City subway system. Grueby and Rookwood produced the tiles for many of the subway stations. Grueby produced the decorative plaques that allow us to recognize the various stops: a ship at Columbus Circle, a beaver, symbol of the Astor family, at Astor Place, the blue sign that announces Bleeker Street, the eagle at 33rd Street, and a number of medallions and smaller signs. It is not known for certain who designed the tile installations, though they were ordered by architects George C. Heins and Christopher Grant LaFarge, respectively brother-in-law and son of John LaFarge, a painter and leader in the American Arts and Crafts movement.[47] They designed the stations, keeping in mind that they had to be concerned with both decoration and clarity, for the stations had to be easily identified visually by passengers, many of whom did not read English. How much input the potteries had in the conception of the design remains to be discovered. Grueby seems also to have produced the tiles used at 116th Street, 28th Street, Brooklyn Bridge, 42nd Street, and 103rd and 110th streets.[48] The installations are an amalgam of styles. The fruit and floral swags are reminiscent of the Della Robbias and the Beaux-Arts style, while the rather baroque flourishes found on some plaques suggest an Art Nouveau source. There are areas with flat, geometric designs that are truly Arts and Crafts in sensibility, and the colors of the Grueby installations leave no doubt as to their source.

Many Grueby tiles are signed with the initials of the decorators, but few of these have been identified. Addison LeBoutillier, an architect, produced particularly graceful designs for tile panels for domestic interiors. One of these, a subtle landscape scene, is now in the Brandwein Collection. This tile would have been a part of a scene created by several tiles, each of which would work well as a single panel as well.

Particularly popular was the Grueby tile depicting a monk playing a cello, which was produced for a number of years. Grueby tiles were hand decorated, with the glazes applied by hand. The fact that Grueby had a fairly wealthy clientele allowed for more hand work than would have been possible in most tile manufactories. The company also did well financially because of the popularity of its green glaze. Once other potteries were able to produce a similar glaze, Grueby's fortunes waned, however. The company was sold in

LEFT ROW: **Group of Art Tiles. J. B. Owens. DECORATIVE TILE. 1909–28. Earthenware, 6" square. Mark:** *OWENS* **impressed on back. Gift of Mary and Paul Brandwein. Grueby Faience. TILE WITH MONK PLAYING CELLO. 1900–1919. Earthenware, 6" square. Mark: none. Gift of Mary and Paul Brandwein. Rookwood Pottery. TILE WITH BASKET OF FLOWERS. 1927. Earthenware, Mark: inaccessible. Gift of Mary and Paul Brandwein**

CENTER ROW: **J. B. Owens. DECORATIVE TILE. 1909–28. Earthenware, H. 6, W. 8½". Mark:** *OWENS* **impressed in relief on back. Gift of Mary and Paul Brandwein. Grueby Faience. TILE WITH BUNCH OF GRAPES. 1900–1919. Earthenware, 6" square. Mark:** *GRUEBY/BOSTON* **impressed on back. Gift of Mary and Paul Brandwein. Rookwood Pottery. TILE WITH PARROT. 1925. Earthenware, 5½" square. Mark:** *Rookwood cipher/XXV/204 3* **impressed on back. Gift of Mary and Paul Brandwein**

RIGHT ROW: **Unknown tile maker. TILE WITH SAILING SHIP. n.d. Earthenware, 4⅛" square. Mark: none. Gift of Mary and Paul Brandwein. Unknown tile maker. TILE WITH GALLEON. n.d. Earthenware, 4" square. Mark: none. Gift of Mary and Paul Brandwein. Enfield Pottery. TILE WITH TULIP MOTIF. Before 1928. Earthenware, 3⅞" square. Mark: none. Gift of Mary and Paul Brandwein. Batchelder Tile Co. REINDEER TILE. c. 1920. Earthenware, 4" square. Mark:** *Batchelder* **impressed on back. Gift of Barbara and Norman Perry**

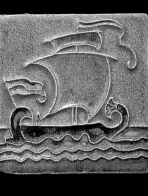

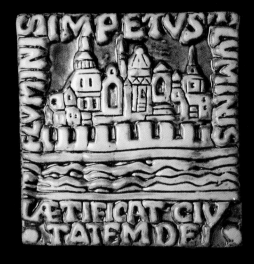

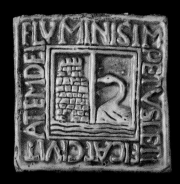

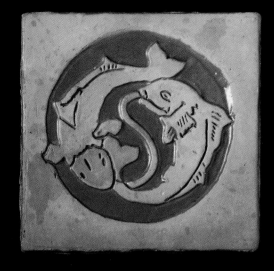

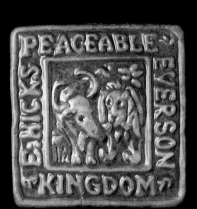

LEFT ROW: **Moravian Pottery and Tile Works. Henry Chapman Mercer, designer. Group of tiles. CITY OF GOD TILE. 1913. Earthenware, H. 5½, W. 5½, D.¼". Mark: *PS 46/4* in pencil on back. Museum purchase. PEACEABLE KINGDOM TILE. Cleota Reed, designer. 1977. Earthenware, 4½" square. Mark: Moravian Pottery cipher/*1977* impressed on back. Museum purchase**

CENTER ROW: **SWAN AND TOWER TILE. 1901. Earthenware, H. 3¾, W. 3¾, D. ½". Mark: none. Museum purchase. TULIP TILE. 1913. Earthenware, H. 2⅜, W. 2⅜, D. ¼". Mark: none. Museum purchase. MUSIC TILE. 1986. Earthenware, 3¼" square. Mark: none. Gift of Mary and Paul Brandwein**

RIGHT ROW: **PISCES TILE. 1914. Earthenware, 5¼" square. Mark: none. Museum purchase. ARIES TILE. 1913. Earthenware, 4⅛" square. Mark: none. Museum purchase**

The Peaceable Kingdom Tile *is a modern piece created by the pottery, which is a living history museum. It was designed on the occasion of the purchase of Edward Hicks's* Peaceable Kindgom *by the Everson Museum of Art in 1977.*

1919 to the C. Pardee Works of Perth Amboy, New Jersey, where the manufactory was relocated.

The C. Pardee Works had been producing art tiles since about 1890–92. It began by making tiles in the Beaux-Arts style, but successfully turned production to accommodate the change in taste with the arrival of the Arts and Crafts aesthetic. A lovely tile with a spiraling vine is glazed in a cool gloss green in the earlier style (1892–1910), while an intaglio tile depicting Grover Cleveland (1894) illustrates the technical virtuosity of the Pardee artists. As at Grueby, the Pardee decorators often initialed their work, but none of them have been identified.

Just as completely handmade art pottery was a rarity, so were completely handmade tiles. However, they were produced, and in some profusion, at the Moravian Pottery and Tile Works in Doylestown, Pennsylvania. Henry Chapman Mercer eschewed the use of machinery in his tile operation (he did relent and used a steam-operated clay grinder), which he had begun in 1898. Mercer was a romantic, an adherent to the philosophy of the Arts and Crafts movement, and well educated in the arts. He was an architect, archaeologist, designer, and scholar. He was also independently wealthy, which allowed him to pursue his interests without much regard to profit making. His pottery was, however, highly profitable.

Well educated and well traveled, Mercer was influenced by medieval architecture, especially that of England, Spain, and France, and by a host of other sources as well, including Pennsylvania German culture.[49] His first tiles were produced from molds taken directly from Pennsylvania German iron stove plates (Mercer was a fanatic collector of early American tools and cultural artifacts). His extensive travels and eclectic interests are reflected in the subject matter he chose to represent on his tiles.

Mercer was intensely interested in medieval tile-making methods, and visited the British Museum and abbeys and churches in England to study pavings. He used only hand production, which resulted in tiles having all the irregularities that so appealed to him in the older tiles. He devised methods of hand production that allowed him to make tiles cheap enough to sell and yet remain true to his artistic principles. He also found it important that his tile installations have some meaning. He wrote that ". . . if tiles could tell no story, inspire or teach nobody, and only serve to produce aesthetic thrills, I would have stopped making them long ago."[50]

This concern with storytelling led to new methods of tile making, for the flat paving tiles limited Mercer's narrative abilities. He devised two pictorial methods resulting in the mosaic style and the brocade style. His mosaics are similar to stained glass, with the individually formed pieces forming a picture and the concrete or grout outlining the forms. In the brocades, each figure is a tile in itself, in high relief, and set into concrete, which becomes the background. With these two methods, he could recount in clay any theme he might fancy. Some of his favorites were the story of the discovery of the New World, the Bible, and activities related to the four seasons. His architectural installations include those at the Isabella Stewart Gardner home in Boston (now the Isabella Stewart Gardner Museum), the state capitol in Harrisburg, and his own

innovative home, Fonthill, in Doylestown, now a museum. Mercer was one of the most original of American craftsmen, and was one of the most important figures in the Arts and Crafts movement in this country.

Mercer inspired Mary Chase Perry to produce her own handmade tiles at her Pewabic Pottery in Detroit. She, too, produced paving tiles, and this led to important commissions in Detroit (St. Paul's Cathedral), St. John the Divine in New York City, and areas of the Shrine of the Immaculate Conception in Washington, D.C. Perry, who became Mrs. William Buck Stratton, was also interested in storytelling, and devised ceramic mosaics inspired by those of Henry Chapman Mercer. In fact, she used Mercer's 1906 catalogue as a source for some of her designs.[51] Pewabic Pottery is still in operation, and many of her molds and designs are still used in production, often for restoration projects. Perry was not so attached to the ideas of strict hand production, and used a variety of automated devices in the preparation of her clays and glazes.

The tile business was a lucrative one for many years, and this inspired a number of art potteries to pro-

Moravian Pottery and Tile Works. Henry Chapman Mercer, designer. THE FOUNTAIN OF YOUTH TILE. 1913. Earthenware set in cement, H. 16, W. 13, D. 1¼". Mark: MR cipher on fountain. Museum purchase

duce tiles in addition to their vessels and other wares. Tiles were a relatively inexpensive way to augment the income of a pottery and required little in the way of additional overhead in an already-established pottery. Thus, many noted potteries, such as Rookwood, Weller, Owens, Teco, and Marblehead made tiles in addition to their customary vessels.

The architectural faience department, as it was called, at Rookwood Pottery began production in 1903, several years after the establishment of the art pottery division. The department made tiles and garden pottery (often on a very large scale), including urns, window boxes, sundial pedestals, fountains and birdbaths, and garden figures. The larger, more mechanized companies that specialized in tile production made competition difficult for Rookwood, but the company was successful in this area until about 1920, when business declined. Rookwood was not as mechanized for tile production as these larger establishments, and their cost-profit ratio was much narrower.

Rookwood tiles were made only with matte glazes, but in a wide variety of colors, soft and subtle, and often created for special orders. They came in various price ranges, with the more expensive colors being shades of red leading to purple. Many of the designs were by special contract, but stock designs were also available in large numbers. Company catalogues reveal that the company made repeat tiles for mantel facings, fireplace surrounds, decorative panels, and reredos. There were stock pieces for moldings, caps, and corner pieces for use with wainscoting, fire openings, and other larger areas. Over one hundred mantel designs were available in stock.[52]

The company created tile decorations for many theaters, department stores, restaurants, churches, residences, and schools. The installations were designed by John Wareham, Ernest Bruce Haswell, Sallie Toohey, and William McDonald, among others. The Brandwein collection has Rookwood tiles depicting a parrot and a basket of flowers, both stylized and glazed with lightly colored matte glazes.

One of the first large contracts was for the New York City subway system, for decorative tiles for the 23rd, 77th, 86th, and 96th Street stations. Later, the company designed the stops at Wall Street and Fulton Street. The plaque that identifies the Wall Street stop illustrates the gables of a Dutch house, before which stands the wall that served as a palisade at the northern edge of New Amsterdam and which gave Wall Street its name. The plaque at the Fulton Street stop illustrates Robert Fulton's steamship *North River Steam Boat* as it plies the waters of the Hudson River.

Owens and Weller also produced tiles, not surprising since they were centered in the largest tile producing area in the world. J. B. Owens began to make tiles under the name of the Zanesville Tile Company about 1905. At this time, cheaper lines of Owens art pottery were dropped, and efforts were made to produce only the highest quality of art ware. The Zanesville Tile Company was so successful financially that it was purchased by a syndicate and closed, effectively eliminating its competition.[53] Two years later, Owens opened another tile plant, the J.B. Owens Floor and Wall Tile Company, which was later renamed The Empire Floor

and Wall Tile Company. This company was very successful and expanded under other names into other states.

The production of the various Owens tile works included tiles with decoration done in both the relief methods and with decals. They were influenced greatly by the other tile makers of the era, both as to technique and style. There are two tiles with graceful, flowing designs in the Brandwein Collection, both revealing the influence of Grueby in the glazes. The company fell prey to the economic conditions of 1929, and closed in that year.

Weller, always in the lead, also produced tiles, including portrait tiles in relief with monochrome gloss glazes, and pictorial tiles, many of which could be used singly as wall plaques. Enfield Pottery in Enfield, Pennsylvania, produced tiles often confused with Moravian tiles. Enfield was influenced by the work of Mercer, and the small tile in the Brandwein Collection betrays Pennsylvania German influence, a culture closely observed by Mercer and which influenced his tile designs. This tile is impressed with the Enfield name on the back. The opaque glaze is typical of Enfield, and was also used on the artware produced by the pottery. Enfield products were hand built, like those of the Moravian Pottery.

On the West coast, Arequipa (founded by Frederick Hurten Rhead) and Batchelder made tiles, handmade to a degree. Ernest A. Batchelder was an adherent of the Arts and Crafts Movement, and the tiles produced by his manufactory were hand pressed in plaster molds. The clay material is always apparent, and plays a very important part in the aesthetics of the finished product. The motifs are in relief, with colored engobes (liquid clays) adding contrast in the background.

AMERICAN ART POTTERY AND THE AMERICAN TILE INDUSTRY

For two seemingly compatible medium, it is interesting that as industries pottery and tiles grew in nearly completely different directions. Whereas the art pottery movement began with handcrafted wares and evolved into mass-produced objects, the tile industry began with mechanized factory production and moved into handmade tiles some years later. In both cases, however, the evolution of style was similar. The earlier high-gloss glazed wares gave way to subdued matte glazes as the Art and Crafts influence was felt by both industries and each accommodated their production to the prevailing changes in American taste. Art pottery was the first truly American style and its appeal remains high today.

NOTES

1. Paul Evans, *Art Pottery of the United States*, 2d ed. (New York: Feingold & Lewis, 1987), 66.

2. Ibid., 266.

3. Cleota Reed, *Henry Chapman Mercer and the Moravian Pottery and Tile Works* (Philadelphia: University of Pennsylvania Press, 1987), 72.

4. Susan Martha Smith, "Roseville: Responses, References and Reflections." (Master's thesis, Syracuse University, N.Y., 1993), 232.

5. Evans, 325.

6. Smith, 237.

7. Peg Weiss, ed. *Adelaide Alsop Robineau: Glory in Porcelain* (New York: Syracuse University Press, 1981), 101.

8. Smith, 231.

9. Weiss, 33.

10. Smith, 246.

11. Edwin Atlee Barber, "The Pioneer of China Painting in America," *The Ceramic Monthly* II (September 1895): 5–20.

12. William Hosley, *The Japan Idea: Art and Life in Victorian America* (Hartford, Conn.: Wadsworth Athenaeum, 1990), 121.

13. Kenneth R. Trapp, "Rookwood Pottery: The Glorious Gamble," *Rookwood Pottery: The Glorious Gamble* (New York: Rizzoli International Publications, 1992), 18.

14. Anita J. Ellis, "Eight Glaze Lines: The Heart of Rookwood Pottery," *Rookwood Pottery: The Glorious Gamble* (New York: Rizzoli International Publications, 1992), 53.

15. Scott H. Nelson et al., *A Collector's Guide to Van Briggle Pottery* (Indiana, Penn.: The A. G. Halldin Publishing Co., 1986), 49.

16. Smith, 222.

17. Ibid., 224 n. 236.

18. *The Courier*, Zanesville, Ohio, 15 Sept. 1898.

19. Evans, 266–67.

20. Smith, 224.

21. Evans, 46.

22. Lloyd E. Hawes, *The Dedham Pottery and the Earlier Robertsons's Chelsea Potteries* (Massachusetts: Dedham Historical Society, 1968), 38.

23. Evans, 109.

24. Garth Clark and Margie Hughto, *A Century of Ceramics in the United States: 1878–1978* (New York: E. P. Dutton / Everson Museum of Art, 1979), 295.

25. Robert W. Blasberg, *Grueby* (Syracuse, N.Y.: Everson Museum of Art, 1981), 19.

26. Evans, 282.

27. Ulysses G. Dietz, "Art Pottery 1880–1920," *American Ceramics: The Collection of Everson Museum of Art* (New York: Rizzoli International Publications, 1989), 65.

28. Edwin Atlee Barber, *Marks of American Potters* (Philadelphia: Patterson and White, 1904), 155.

29. Seymour Altman and Violet Altman, *The Book of Buffalo Pottery* (New York: Bonanza Books, 1969), 76.

30. Ibid., 21.

31. Evans, 70.

32. Ibid., 71.

33. Ibid., 243.

34. Weiss, 111.

35. Samuel Robineau, quoted in Weiss, 25.

36. See Richard Zakin, "Technical Aspects of the Work of Adelaide Alsop Robineau" in Weiss, 117–38.

37. Jill Austwick and Brian Austwick, *The Decorated Tile: An Illustrated History of English Tile-making and Design* (Don Mills, Ontario: Collier MacMillan Canada Ltd., 1980), 35.

38. Evan Purviance and Louise Purviance, *Zanesville Art Tile in Color* (Des Moines, Iowa: Wallace-Homestead Book Co., 1972), plate 6.

39. Ibid., plate 8.

40. Lisa Taft, *Herman Carl Mueller* (Trenton: New Jersey State Museum, 1979), 6

41. Sharon Dale, *Frederick Hurten Rhead: An English Potter in America* (Pennsylvania: Erie Art Museum, 1986), 112.

42. Austwick, 107.

43. Taft, 18.

44. Ibid., 7.

45. Evans, 151.

46. Alice Cooney Frelinghuysen, *American Porcelain: 1770–1920* (New York: Metropolitan Museum of Art, 1989), 166.

47. Lee Stookey, *Subway Ceramics: A History and Iconography*, 2d ed. (Brattleboro, Vt.: Lee Stookey, 1994), 14.

48. Ibid., 16.

49. Reed. This important comprehensive study of Mercer and his work details these influences and their expressions in the tiles produced at the Moravian Pottery.

50. Letter from Mercer to William Hagerman Graves, 1925, see Reed, 236.

51. Reed, 82.

52. Herbert Peck, *The Book of Rookwood Pottery* (New York: Bonanza Books, 1968), 162.

53. Evans, 209.

SELECTED BIBLIOGRAPHY

Altman, Seymour, and Violet Altman. *The Book of Buffalo Pottery.* New York: Bonanza Books, 1969.

Austwick, Jill, and Brian Austwick. *The Decorated Tile: An Illustrated History of English Tile-making and Design.* Don Mills, Ontario: Collier MacMillan Canada Ltd., 1980.

Barber, Edwin Atlee. *Marks of American Potters.* Philadelphia: Patterson and White, 1904.

————. *The Pottery and Porcelain of the United States: An Historical Review of American Ceramic Art from the Earliest Times to the Present Day.* 3d ed. rev. and enl. New York: G. P. Putnam's Sons, 1909.

Blasberg, Robert W. *Grueby.* Syracuse, N.Y.: Everson Museum of Art, 1981.

Blasberg, Robert W., and Carol L. Bohdan. *Fulper Art Pottery: An Aesthetic Appreciation, 1909–1929.* New York: Jordan-Volpe Gallery, 1979.

Bruhn, Thomas P. *American Decorative Tiles, 1870–1930.* Exh. cat. Storrs, Conn: The William Benton Museum of Art / The University of Connecticut, 1979.

Burke, Doreen Bolger et al. *In Pursuit of Beauty: Americans and the Aesthetic Movement.* New York: Metropolitan Museum of Art / Rizzoli International Publications, 1986.

Cincinnati Art Museum. *The Ladies, God Bless 'Em: The Women's Art Movement in Cincinnati in the Nineteenth Century.* Ohio: Cincinnati Art Museum, 1976.

Clark, Garth. *American Ceramics: Eighteen Seventy-Six to the Present.* New York, Abbeville Press, 1987.

Clark, Garth and Margie Hughto. *A Century of Ceramics in the United States: 1878–1978.* New York: E. P. Dutton / Everson Museum of Art, 1979.

Clark, Garth, Robert A. Ellison, Jr., and Eugene Hecht. *The Mad Potter of Biloxi: The Art and Life of George E. Ohr.* New York: Abbeville Press, 1989.

Clark, Robert Judson, ed. *The Arts and Crafts Movement in America, 1876–1916.* Exh. cat. New Jersey: Princeton University Press, 1972.

Cooper-Hewitt Museum. *American Art Pottery.* Exh. cat. New York: Cooper-Hewitt Museum / University of Washington Press, 1987.

Dale, Sharon. *Frederick Hurten Rhead: An English Potter in America.* Pennsylvania: Erie Art Museum, 1986.

Darling, Sharon S. *Chicago Ceramics and Glass.* Illinois: Chicago Historical Society, 1979.

Dietz, Ulysses G. "Art Pottery 1880–1920." In *American Ceramics: The Collection of Everson Museum of Art,* edited by Barbara Perry. New York: Rizzoli International Publications, 1989.

Doat, Taxile. *Grand Feu Ceramics: A Practical Treatise on the Making of Fine Porcelain and Grès.* Translated by Samuel E. Robineau. Syracuse, N.Y.: Keramic Studio Publishing Company, 1905.

Eidelberg, Martin, ed. *From Our Native Clay: Art Pottery from the Collections of the American Ceramic Arts Society.* New York: American Ceramic Arts Society / Turn of the Century Editions, 1987.

Ellis, Anita J. *Rookwood Pottery: The Glorious Gamble.* New York: Rizzoli International Publications, 1992.

Evans, Paul. *Art Pottery of the United States: An Encyclopedia of Producers and their Marks.* 2d ed. New York: Feingold & Lewis, 1987.

Frelinghuysen, Alice Cooney. *American Porcelain: 1770–1920.* Exh. cat. New York: The Metropolitan Museum of Art, 1989.

Henzke, Lucile. *American Art Pottery.* Camden, N.J.: Thomas Nelson, 1970.

Hillier, Bevis. *The Social History of the Decorative Arts: Pottery and Porcelain, 1700–1914.* New York: Meredith Press, 1968.

Hosley, William. *The Japan Idea: Art and Life in Victorian*

America. Hartford, Conn: Wadsworth Athenaeum, 1990.

Huxford, Sharon, and Bob Huxford. *The Collectors Encyclopedia of Roseville Pottery.* Paducah, Ky.: Collector Books, 1976.

Kaplan, Wendy, ed. *The Art That is Life: The Arts & Crafts Movement in America, 1875–1920.* Boston: Museum of Fine Arts, 1987.

Keen, Kirsten Hoving. *American Art Pottery, 1875–1930.* Wilmington: Delaware Art Museum, 1978.

McLaughlin, M. Louise. *Pottery Decoration under the Glaze.* Cincinnati, 1880.

Nelson, Scott H. et al. *A Collector's Guide to Van Briggle Pottery.* Indiana, Penn.: The A. G. Halldin Publishing Co., 1986.

Nichols, George Ward. *Pottery: How It Is Made, Its Shape and Decoration, Practical Instructions for Painting on Porcelain and All Kinds of Pottery with Vitrifiable and Common Oil Colors.* New York: G. P. Putnam's Sons, 1878.

Peck, Herbert. *The Book of Rookwood Pottery.* New York: Bonanza Books, 1968.

———. *The Second Book of Rookwood Pottery.* Tucson, Ariz., 1985.

Perry, Barbara, ed. *American Ceramics: The Collection of Everson Museum of Art.* New York: Rizzoli International Publications, 1989.

———. *Fragile Blossoms, Enduring Earth: The Japanese Influence on American Ceramics.* Exh. cat. Syracuse, N.Y.: Everson Museum of Art, 1989.

Purviance, Evan, and Louise Purviance. *Zanesville Art Tile in Color.* Des Moines, Iowa: Wallace-Homestead Book Co., 1972.

Purviance, Evan, Louise Purviance, and Norris F. Schneider. *Zanesville Art Pottery in Color.* Des Moines, Iowa: Wallace-Homestead Book Co., 1968.

Reed, Cleota. *Henry Chapman Mercer and the Moravian Pottery and Tile Works.* Philadelphia: University of Pennsylvania Press, 1987.

Robineau, Adelaide Alsop, ed. *Keramic Studio.* Syracuse, N.Y.: Keramic Studio Publishing Company, 1899–1924.

Smith, Susan Martha. "Roseville: Responses, References, and Reflections." Master's thesis, Syracuse University, N.Y., 1993.

Stookey, Lee. *Subway Ceramics: A History and Iconography.* 2d ed. Brattleboro, Vt.: Lee Stookey, 1994.

Trapp, Kenneth R. *Ode to Nature: Flowers and Landscapes of the Rookwood Pottery, 1880–1940.* New York: Jordan-Volpe Gallery, 1980.

———. "Rookwood and the Japanese Mania in Cincinnati." *The Cincinnati Historical Society Bulletin* 39 (Spring 1981): 51–75.

———. *Toward the Modern Style: Rookwood Pottery, The Later Years, 1915–1950.* New York: Jordan-Volpe Gallery, 1983.

Van Lemming, Hans. *Victorian Tiles.* Aylesbury, England: Shire, 1981.

Weiss, Peg, ed. *Adelaide Alsop Robineau: Glory in Porcelain.* New York: Syracuse University Press / Everson Museum of Art, 1981.

Published on the occasion of the exhibition
"American Art Pottery from the Permanent Collection of Everson Museum of Art,"
January 24–August 24, 1997

Editor: RUTH A. PELTASON

Designer: ANA ROGERS

Library of Congress Cataloging-in-Publication Data

Everson Museum of Art.
American art pottery : from the collection of Everson Museum of
Art / by Barbara A. Perry ; photographs by Courtney Frisse.
p. cm.
Includes bibliographical references.
ISBN 0–8109–1971–0 (clothbound)
1. Art pottery, American—Catalogs. 2. Pottery—New York (State)—
Syracuse—Catalogs. 3. Everson Museum of Art Catalogs.
I. Perry, Barbara (Barbara Stone) II. Title.
NK4007.E94 1997
738.3' 0973' 07474766—dc20 96–36452

PAGE 2: **Stangl Pottery Company. VASE. Stoneware, H.6¼, W. 4¼, D. 2½". Mark: none. Gift of Mary and Paul Brandwein**
This stunning Art Deco–style vase illustrates the expert use of glazes by the Fulper and Stangl potteries.

PAGE 3: **Van Briggle Pottery. Artus Van Briggle, designer. LORELEI VASE, designed 1901. Earthenware**

Published in 1997 by Harry N. Abrams, Incorporated, New York
A Times Mirror Company

Printed and bound in Hong Kong